THANK YOU FOR YOUR CONTINUED INTEREST

GORSKY PRESS
LOS ANGELES • CALIFORNIA
2003

THANK YOU FOR YOUR CONTINUED INTEREST

copyright © Rev. Richard J. Mackin, 2003

Copyright 2003 for all the stuff written by me. I don't see how I can copyright the stuff written TO me, since I didn't write it. Please remember that a copyright is not the same as a copywriter, who is the person who writes the words in ads and packaging.

Earlier versions of "Beyond Rock and Roll," "Road Trips Are Good for the Soul," and "Random Thoughts on Bikes" appeared in *Razorcake Magazine*. An earlier version of "Here We Are Now, Entertain Us!" appeared in *Suburban Voice*. Richard Mackin writes regular columns for both magazines.

Cover Artwork by Rev. Richard J. Mackin
Cover Design by Sean Carswell

ISBN 0-966-8185-7-1

Gorsky Press
PO Box 42024
LA, CA 90042
www.gorskypress.com

THANK YOU LIST

For Sean and Todd, without whom I would be photocopying this at Amy's office.

For Amy, who would gladly let me make all the ill gotten copies I want.

For Josh for his passion, and Steve B for teaching about Compassion.

For Janaka, for being the greatest monkey-fighting haiku champ I ever had the pleasure to live and tour with.

and thank YOU, whether your interest continues or not.

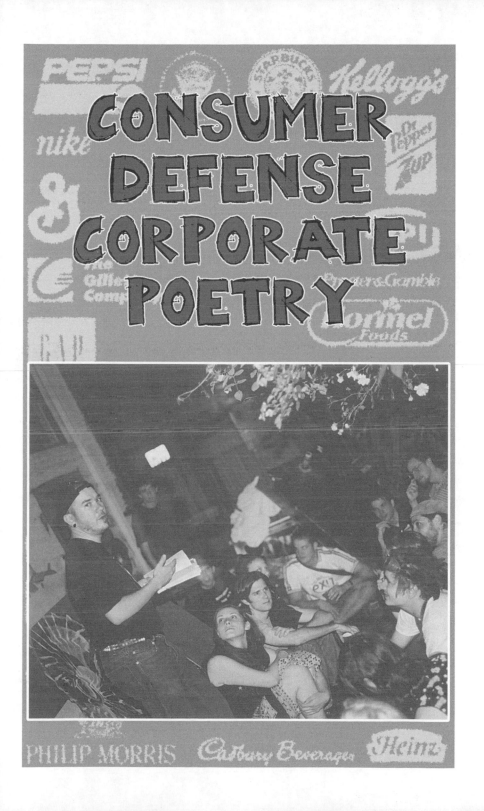

Dear Cambell's Soup Mar. 31, 1997

I was watching TV and a familiar ad came on. It was your tomato
soup commercial in which there is a kid "at camp" in a leaky
tent in the rain, writing a sad letter to mom ,as all kids do,
because camp basically sucks as a concept, and it is even worse
since it is told to be fun. But anyway, he is sad and getting
wet, but is pleasantly suprised to see MOM entering the tent
armed with a warm bowl o' soup. Ironically, the kid is only
camping out in the back yard. He is not away at all! He was
only writing a letter as a bit of make belief! How crazy funny!
Who woulda figured! But then comes the insult. In response to
the soup, he exclaims, "you're the best mom!" Now that says
to me that my own mother is not the best. Since this is the
last thing said, it may even be thought that the whole ad was
build up to the fact that this kid has the BEST mother. Well,
I think that it is presumptuous and unfair to proclaim this
just because you have millions of dollars to take out ads. I
am not going to be so bold as to say MY mother is the best,
as good as she is, I just think that you should have some kind
of public contest before deciding the winner.

Please respond,

Richard Mackin
1298 Commonwealth Ave #4
Allston MA 02134

P.S.If she really was the best mom, would she let her kid sleep
in a leaky tent in the rain?

7

Campbell Soup Company

Consumer
Response &
Information
Center

April 22, 1997

Mr. Richard Mackin
1298 Commonwealth Ave. #4
Allston, MA 02134

Dear Mr. Mackin,

Thank you for taking the time to contact us regarding our
new advertising campaign for Campbell's Tomato Soup.

We apologize if you feel the commercial conveys an
unclear message. Certainly that was not our intention.

We thoroughly test all commercials with consumers of all
ages before they air. Our testing has shown that consumers
enjoy advertising, and view them with a warm and friendly
feeling.

Thank you once again for taking the time to contact us.
We appreciate your sharing your comments with us and we will
consider them as we develop future advertising efforts.

Please enjoy the enclosed coupon which can be used toward
the purchase of one of our many favorite Campbell products.

We trust that you will continue to use and enjoy
Campbell's high quality products.

Sincerely,

Marie H. Jennings
Consumer Representative
0015909740

Enclosed: $.50 coupon(s)

Dear Mountain Dew, Feb 6,1995

Okay, say I wanted some soda that tasted like oranges. I would
buy orange soda. Same with lemon lime soda, cola, grape, and
asorted "beer" and "ale" sodas. So what the hell flavor is
Mountain Dew? I mean, actual dew from actual mountains would
be kinda gross, don't you think? Please write back.

Thank you.

Rich Mackin
1191 Boylston st 33
Boston, MA 02215

April 11, 1995

Mr. Rich Mackin
1191 Boylston Street -- #33
Boston, MA 02215

Dear Rich:

Thank you for taking the time to write to us here at Pepsi-Cola regarding the name and
flavor of Mountain Dew.

Mountain Dew is a full flavored carbonated soft drink with its own unique citrus taste.
Its primary citrus flavoring is concentrated orange juice. Pepsi-Cola Company
acquired the brand in 1964 from the Tip Corporation. Originally the brand had strong
regional popularity in the South, but has recently grown to be the fifth best selling soft
drink in the United States.

Thanks again for writing; we appreciate your interest in Pepsi products. I hope we
can count on your continued friendship and support.

Sincerely,

Joe McGovern
Consumer Relations

9

```
Frito-LAY,Inc.
7701 Legacy Drive                              Nov 13,1994
Plano, Texas 750.24

Dear Lays,

I ate just one.

IN YOUR FACE!!!

Please Respond,
```

NO REPLY!

```
Richard J. Mackin
1191 Boylston st 33
Boston,Ma 02215
```

Dear Coca Cola

While discussing your "Always Coca Cola" campaign with a six grader, he brought up that "the only true constant is change" and this you can't really ALWAYS be Coca Cola.

This lead me to consider that as a beverage, Coca Cola is intended to be consumed and merge with the human body, being broken down into base components, and used or disposed by the body. Thus, not being Coca Cola for very long, certainly not Always being Coca Cola.

Sad that it takes a 13 year old kid to show us all up like that.

Sincerely,

Rich Mackin
PO Box 890 NO REPLY!
Allston MA 02134

10

Mar 7, 1995,

Dear Advil,

I was watching T.V. and I saw your ad about how people who consume 3 or more alchoholic beverages a day on a regular basis should not use Tylenol, but could use ADVIL more safely. Hooray for you! Advertising is GREAT! Capitalism is GREAT! People who are drinking 3 or more drinks a day shouldn't cut down, the only health issue that they have is painkillers.

I love advertising so I offer some suggestions for future ads...

1)ADVIL-the drunkard's choice.
2)Drunken stupor all night, dry heaving all day can give you a terrible headache, but with ADVIL, you'll be fine and ready for happy hour!
3)It's noon. You just woke up in a stranger's house wearing a toga. You're not sure what that taste in your mouth is, but you're sure about that headache. It's ADVIL time.
4)...and then afterwards open another kind of bottle
5)ADVIL, now availiable at bars and liquor stores everywhere
6)No matter what your age, nobody cards for ADVIL
7)Too much ale or too much wine, but with ADVIL you feel fine
8)Hey, ever see TED KENNEDY with a headache? ADVIL!
9)The braincells that are still alive are screaming for relief! Take ADVIL!
10)Lick it! Suck it! Slam it! ADVIL!

Please let me know before you air any of these commercials so I can set my VCR.

Thank you. Please reply A.S.A.P.

NO REPLY!

Rich MAckin
1298 Commonwealth Ave #4
Allston MA 02134

11

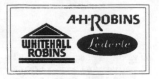

Product Quality
1407 Cummings Drive
P.O. Box 26609
Richmond, Virginia 23261-6609
Telephone (804) 257-2000

December 17, 1996

Richard J. Mackin
1298 Commonwealth Ave
4
Allston, MA 02134

Dear Mr. Mackin:

Thank you for taking the time to write to us.

We appreciate your comments and your taking the time to express your opinion. Feedback from our consumers is very important to us. Your letter has been referred to our Advertising Department.

In appreciation of your comments, we are sending you a complimentary product, as well as coupons that you may use toward the purchase of various Lederle Consumer Health and Whitehall-Robins Healthcare products.

Whitehall-Robins Healthcare is firmly committed to the manufacture and sale of only the finest quality products and is grateful that you brought this matter to our attention. Should you have additional questions, please call 1-800-88-ADVIL (1-800-882-3845). Our offices are open weekdays, 9:00 a.m. to 5:00 p.m. EST.

Sincerely,

Carol Miller

Carol Miller
Information Specialist

1 Advil® Tablets 0150-20 N/A 24s
1 Cents-Off Coupon Multiple Coupon Sheet D-0161 Exp.none

9602100457

12

May 10,1995

Dear Wrigley people,

So I was watching TV and one of your commercials come on. You know, in your current ad campaign targeting smokers, figuring that anyone stupid enough to waste their money on carcinogens wouldn't mind wasting some on gum, and if they can't smoke in a given situation, then chewing gum is a practical alternative or at least distraction. Anyhoo, the thing is, this ad mentioned being in a fast food restaurant that is no smoking, so chew wrigley's instead. But if you were in a fast food restaraunt, when would you have time to chew gum? You go in, you eat, you leave. Am I missing something?

Please Respond,

Dan Sibley
109 Peterborough #2
Boston MA 02215

13

Wm. **WRIGLEY** Jr. Company

WRIGLEY BUILDING • 410 N. MICHIGAN AVENUE
CHICAGO, ILLINOIS 60611

Telephone: 644-2121
Area Code 312

WHOLESOME • DELICIOUS • SATISFYING

August 2, 1995

Mr. Dan Sibley
109 Peterborough #2
Boston, MA 02215

Dear Mr. Sibley:

Thanks for writing to comment on our television commercial for
Wrigley's Spearmint gum. We appreciate your taking time to
write.

While we know that some people leave a restaurant immediately
after finishing their meals, we also know that others prefer to
linger. And since many restaurants have prohibited smoking,
Wrigley's Spearmint is an alternative for these folks. It helps
freshen their breath after a meal, too!

Thanks again for sharing your thoughts with us. With the hope
you'll enjoy them, several fresh packs of Wrigley's Spearmint gum
will soon be on their way to you, with our very best wishes.

Sincerely yours,

WM. WRIGLEY JR. COMPANY

Barbara C. Zibell
Consumer Affairs Administrator

BCZ/sl

14

May 26,1995

Dear Mop & Glo

I am appalled by your current and offensive new T.V. ad.

It starts out with a fat guy walking into his kitchen to grab
a midnight snack. He is not fat because of an eating disorder
or glandular problem, he is fat because he eats cake in the
middle of the night. Yeah, right, real nice.

So he steps on his floor and feels that it is sticky. It is
sticky because he used a product that was not Mop & Glo. Luckily,
even though he obviously prefers the other product, he always
has some Mop & Glo handy, and seeing that it is only 4 am, he
might as well mop the kitchen before he eats his snack. He might
as well, since he is fat. Obviously you don't think that he
has someone waiting in bed for him. And doesn't he need rest?
What day of the week is this? Doesn't he have to go to work
the next day? Maybe it is Friday night, and since he is fat,
he doesn't have any social activities, because in T.V. land,
the obese are joke material, not human beings.

And of course, the commercial finishes with him eating cake.
Let him eat cake. Fat guy eating cake alone at night, the only
thing going for him in life is the delicious, although fatty,
cake, and the clean, nonsticky floor he stands on.

I don't know. Maybe if you want fat people to use your product,
you should depict them in a better light.

Please Respond,

Richard J. Mackin
1191 Boylston #33
Boston MA 02215

15

RECKITT & COLMAN

July 13, 1995

Mr. Richard Mackin
1191 Boylston #33
Boston, MA 02215

Dear Mr. Mackin:

Thank you for your comments about the television commercial for our product, Mop & Glo Floor Cleaner.

We are naturally sensitive to any criticism and sincerely regret that you found this commercial not to your liking. We realize that not every commercial message will gain the approval of every viewer, but we are proud that most of our commercials have been well received by the public.

Your taking the time to write to us is appreciated. We are reliant upon public opinion and consider your views helpful in determining our future messages.

Sincerely,

Marianne Hever
Consumer Relations

9500182150

RECKITT & COLMAN INC.
225 Summit Avenue, Montvale, NJ 07645-1575 201-573-5700

June 1,1995

Dear Schwepps,

Regarding your new T.V. ad featuring the song "Space Oddity"
by Mr. David Bowie; not only is this one of those damnable
sellout corporate Satan commercials that take classic songs
that everybody has personal memories of, and then whore the
whole thing off for your crappy product. I don't think about
wanting your product because I like the song, I think about
how sad it is that Artists sell out. But all this is besides
the point.

In this ad, a bottle of soda is made to look like a rocket,
while "Space Oddity" with its story of a rocket plays in the
background. What you advertising idiots didn't seem to notice
is that the rocket breaks, and Major Tom floats away in space
to die. What a horrible metaphor for a product.

Please go back to the ads with the Monty Python guy making fun
of Americans.

Please Respond,

Richard J.Mackin
1191 Boylston St #33
Boston, MA 02215

17

Cadbury Beverages

CADBURY BEVERAGES INC.

6 HIGH RIDGE PARK
POST OFFICE BOX 3800
STAMFORD, CONNECTICUT 06905-0800
PHONE (203) 329-0911
TELEX 965904
FAX (203) 968-7653

June 29, 1995

Mr. Richard Mackin
1191 Boylston Street
#33
Boston, MA 02215

Dear Mr. Mackin:

We received your letter regarding Schweppes television advertising
and want to thank you for taking the time to tell us your reaction.

We regret that you were disappointed in our advertisement. Our
advertising is carefully reviewed and tested to ensure that our
standards are maintained; we hope that the decisions made
regarding our advertising will reflect favorably on the Company and
its products.

It is to be expected that our advertising choices will occasionally
differ from the expectations of a portion of the audience. Our
consumers' comments are always welcome, and your views will be
considered in future campaigns.

Again, we appreciate receiving your comments. Please accept the
enclosed coupons with our many thanks.

Sincerely,

Carol Dawson

Carol Dawson
Consumer Services Representative
Enclosure

A MEMBER OF THE CADBURY SCHWEPPES PLC GROUP

Newsweek Aug 12, 1995
Box 404
Livingston, New Jersey
07039-1676

Dear News People,

A couple of years ago, I thought that getting a subscription
to Newsweek would be a good idea, given your inexpensive
subscription price. I thought that I would benefit from the
regular arrival of important news stories. Instead, I recieved
some news that was hidden between updates on crucial information
that really really affects my life, like Tanya Harding's thoughts
on life, and every time that O.J. Simpson sneezes, coughs or
farts. I also got intelligence-insulting discussion on Generation
X and a curious lack of stories that I find readily in smaller
publications. So, come renewal time, I decided not to revew.
I wrote you, told you that I did not want your magazine anymore,
and while I was at it, I once again mentioned that my name is
MACKIN. MACKIN! **MACKIN!!!** Not Markin! You people are supposably
journalists, investigators of facts, and facts are being
repeatedly thrust in your face, and you don't even notice them!
No wonder NEWSPEAK is such a pathetic publication! Get the hint!
DO NOT SEND ME ANYMORE BILLS FOR A CANCELLED SUBSCRIPTION!!!
LEAVE ME **ALONE**!

And HOW DARE YOU ask me to pay promptly because that would save
you on postage--no follow up reminders! Do you really expect
me to really worry about the few pennies of postage you send
me out of your multi million dollar company. The last concern
I have right now is that NEWSWEEK wastes its money on extranious
postage to bother me with. If you are so concerned with saving
postage, get the point and stop mailing nonsense to a fictional
person whose name resembles mine!

Richard J. MACKIN
1191 Boylston St #33
Boston MA 02215

Newsweek /INVOICE Box 404, Livingston, New Jersey 07039-1676

Number of Issues	Cost Per Issue	TOTAL AMOUNT DUE
XXXXXXXXXX	XXXXXXXX	$27.65

518660048

00086258862 010030 5 0002765000007

Issue/Sub	Cost/Issue	Total
35	$.790	$27.65
Sales Tax		$0.00
Total Order Value		$27.65
Payment Received		$0.00
Total Amount Due		$27.65

MR RICHARD MARKIN
APT 4
1298 COMMONWEALTH AVE
ALLSTON MA 02134-4018

IIl.....l.l....ll.lll..l.l.l..ll.ll.......lll.l.l.l.l..l.l.l..l

PLEASE PAY NEWSWEEK FOR YOUR SUBSCRIPTION RENEWAL, WHILE
THERE'S STILL TIME. RETURN THIS BILL WITH YOUR CHECK
TODAY. THANK YOU.

Detach Here

Newsweek

October 10, 1995

We need to hear from you NOW.

Dear Mr Richard Markin:

Maybe you simply forgot.

At any rate, we need to hear back from you now. Our
records show that we have not yet received payment for your
NEWSWEEK subscription renewal. And, as you know, we cannot
continue service indefinitely if you're not paid up!

I can't help but wonder. Is something wrong?
Are your copies being delivered? Do we have
your correct address? If there is some problem,
please let us know so we can straighten it out
and make any adjustment. If you have any questions
you can phone toll free: 1-800-634-6842.

If, on the other hand, everything's all right and you
are enjoying NEWSWEEK every week, please pay now, while
there's still time. Thank you.

Cordially,

William Barnes

for NEWSWEEK

Dear Cordial Idiot named William Barnes,

Maybe you simply ignored me

At any rate, I DID NOT RENEW MY SUBSCRIPTION TO NEWSWEEK!
Furthermore, I have written to you three times about the fact
that I have not renewed my subscription. I even explicitly
explained to you that I did NOT want to re-subscribe because
of the poor quality of your trashy excuse for reporting. I also
did not want the second subscription that was sent for a while
some months ago.

I especially would like to tell you something...
My last name is MACKIN. MACKIN. Em Ay See Kay Eye En. Not Markin.
MaCkin. It was Mackin when I was born. It was Mackin when I
first subscibed. It was Mackin when I wrote to you that it was
Mackin. It was Mackin when I told you not to send me two copies
and that my name was Mackin. It was Mackin when I wrote to you
to tell you that I did not renew my subscription and that my
name was Mackin. My name is still Mackin. My name will be Mackin
when you write again and ask why Richard Markin is not paying
for a subscription he did not renew.

You are dumb. Leave me alone.

Richard J Mackin
1298 Commonwealth Ave #4
Allston MA 02134.

21

Newsweek /INVOICE Box 404, Livingston, New Jersey 07039-1676

Number of Issues	Cost Per Issue	TOTAL AMOUNT DUE
XXXXXXXXXX	XXXXXXXX	$27.65

618700053 00086258862 010030 6 0002765000005

```
Issue/Sub    Cost/Issue    Total
    35          $.790       $27.65          MR RICHARD MARKIN
Sales Tax                   $0.00           APT 4
Total Order Value           $27.65          1298 COMMONWEALTH AVE
Payment Received            $0.00           ALLSTON      MA 02134-4018

Total Amount Due            $27.65          Ill.....l.l....ll.ll.l.l.l.l.ll.....llll.l.l.l.l..l.l.l....l
```

THIS IS URGENT. PAYMENT FOR YOUR SUBSCRIPTION IS PAST DUE.
PLEASE RETURN THIS INVOICE WITH YOUR CHECK TODAY. ANY
QUESTION? PROBLEM? PHONE TOLL-FREE 1-800-634-6842.

Detach Here

Newsweek November 7, 1995

Please pay this bill
and do YOURSELF a favor!

Dear Mr Richard Markin:

Not interested in the news any more? Not interested
in people? Money? Politics? Business? Medical break-
throughs? Don't want the details behind the headlines, the
information that goes beyond the news briefs you see on TV?

Maybe that's why you haven't paid for your NEWSWEEK
subscription renewal.

Seriously, you did renew. And for very
good reasons. To keep abreast. Keep in
touch. Be in the know. To remain aware of
everything that's happening all around you.
To understand it all.

So do YOURSELF a favor. Complete the renewal process
and pay for your subscription now. (If you have a question
about your subscription, phone toll-free 1-800-634-6842.)

Cordially,

William Barnes

for NEWSWEEK

22

NewSpeak
Box 404
Livingston, NJ 07039-1676

Dear Silly People,

Not interested in stupidity any more? Sick of hearing about
O.J. Simpson while government steals away people's money and
freedom? Sorry attempts at reporting interspliced with 2 bit
pieces of pop culture better discussed in honest exploiters
of pop culture? Don't I want the same crud I could get on T.V,
but for FREE? NO! No, No, and for the last time, NO!

I haven't paid my Newsweek subscription renewal because
I DID NOT RENEW MY SUBSCRIPTION!!!

Seriously, I did not renew. And for very good reasons. Because
you are a bad magazine. Because you keep misspelling my name.
Because you have a subscription department that doesn't seem
to read it's incoming mail.I do not know how to explain this
any more blatantly than I have in previous letters.

So do YOURSELVES a favor. First, change my name in you files
to what it is supposed to be, Ma C_ kin. Then, make sure that
you do not ever send me anything ever again. (I have called
your toll-free number, but alas, it only operates while I am
at work and cannot call silly company operators.)

I wish I had the time and/or effort to print my name in a
different color so that it actually looked like I signed this,
as would the ever-cordial but perpetually inactive William
Barnes.

Richard J. Mackin
1298 Commonwealth Ave #4
Allston MA 02134

P.S. Since I have little faith that this will actually be read,
I will end as such...
Lal
alalalalalalalalalalalalalalalalallalalalalalalalalalalalalalal
ala
lal
alalala la lolly lolly la.

NO REPLY!

Dear Microsoft, Jan 15, 1999

Do you find any irony in the fact that the name of one of the most powerful
entities in the world means "small" and "gentle"?

Please respond,

Rich Mackin
P.O.Box 890
Allston MA 02134

NO REPLY!

McDonald's
Kroc Drive
Oak Brook, IL 60523

Dear McDonald's

You have built a McDonald's in my neighborhood.

Please remove it.

Rich Mackin
POBox 890
Allston MA 02134

NO REPLY!

Jan 8, 2001

James Coppola Matthew M Bondi
237 Strawberry Hill Ave 5 Tulip Lane
Norwalk Ct 06855 Norwalk Ct 06855

Dear James and Matthew

I am writing to you in regard to the Norwalk Citizen News Vol 5 issue 52 dated December 28, 2001 in which you were listed as "The Reindeer Molesters".

I am writing to you to make fun of the fact that you were arrested on trespassing and vandalism charges for sexually molesting reindeer yard decorations this Xmas season.

At this point you might be wondering, is he making fun of us for our depravity, for getting caught, or for the fact that we were dumb enough to videotape ourselves, thus providing huge amounts of evidence for the cops. Actually none of the above, I am writing because I think it was a sad waste of creative vandalistic energy to merely videotape yourselves molesting fake animals when with the same risk and energy you could have...

- Targeted specific enemies by waiting for a good snow and make snow men who were molesting the reindeer and thus remain to be discovered.
- Steal all the " house for sale" signs in town and keep putting one up at a specific home, replacing it as the owner removes it each day.
- Liberate a number of gas station flags, signs and other such ephemera and set up the residence of your choice to appeal all gas stationy.
- Steal all the neighborhood crime watch signs from a given neighborhood.
- Removed all the pumpkins in town a day or two after Halloween and left them all on a pile on the Westport golf course.
- Make and install "go" signs midway on any block.
- Kidnapped a fake reindeer and sent the owner polaroids of it in various situations for a year, after which you return it.
- Claimed a traffic island as a free nation and lived in anarchist paradise until the cops make you leave.
- Put a whole lot of bubble bath in a public fountain.
- Made and distributed false sale flyers or coupons for the evil company of your choice.
- Painted a artistic graffiti mural over the billboard(corporate graffiti) of your choice.
- Done some sort of political action that actually would have made a statement, like locking the doors of any evil corporation franchise.

So shame on you, you could have been heroes, freedom fighter, artists, but instead you are just some dumb kids who will be remembered for humping lawn ornaments.

(Not that I endorse any sort of law breaking or vandalizing, I am just saying is all.)

Rich Mackin
POBox 890
Allston MA 02134

NO REPLY!

25

Dec 26, 2001

Xerox Company
800 Long Ridge Road,
Stamford, CT 06904

Dear Xerox

I just read something to the effect of
"The Xerox Corporation has taken out ads in major newspapers, pleading 'Please don't use our name as a verb, as in 'Xerox this.' The Xerox Corporation has a major trademark problem on its hands; people commonly say 'Make a Xerox of this' even if they are referring to use of a copy machine of an entirely different brand name, i.e., the term 'Xerox' is in danger of becoming the generic word for making copies."

What you don't seem to understand, is that this is your problem, not the average person's. In fact, I have it on good authority that their are many people out there that don't even LIKE corporations, you know, like the kids that smashed Starbucks in Seattle a few years ago. Do you realize that what you are doing is letting these people know the way to destroy your company? Does Dracula take out ads telling people to please not bring garlic near him? Did Darth Vader take out ads telling the Rebel Alliance not to exploit the weakness of the Death Star? NO! It would be like telling robbers what part of the house you hide the jewels in, and then warning them to stay away from that part.

What you need to be is proactive. Instead of telling people what not to do, which will make them just do it even more, like when Philip Morris makes those really lame "We Card" and "Think, Don't Smoke" campaigns that are so annoying that even nonsmokers want to light up in defiance. Reverse psychology works for them since they really don't want kids to not smoke...but it backfires for you.

Instead of telling us what not to do, you need to tell us what to do! Now, you can use the non brand specific word for photocopying...xerography, but that is similar enough to Xerox, so I propose you call these things Carlsons, after physicist and patent attorney Chester F. Carlson , who invented the process in 1937. Since he was a patent attorney, you know he knew what was up in terms of copyright!

NO REPLY!

Rich Mackin
POBox 890
Allston MA 02134

P.S. Since I made a Carlson of this on a Xerox machine, is it a Xerox in this case?

26

Kelloggs June 26, 1996
Battle Creek, MI
49016

Dear Kelloggs Corn Pops,

I was walking down the aisle of cereal in my grocery store,
and I noticed the new Corn Pops box top. I am sure that you
are happy to hear that I noticed the box, as I normally wouldn't
have. You see, I dislike the way the things taste, and
furthermore fall out of your demographic. (The ads would appear
targeted towards obsessive addictive personalities who distrust
siblings and other acquaintances)

An ad synopsis- "you ate the last bowl of Pops!?! ARRRGH! What
am I gonna do? grunt grunt grunt. Oh, there's actually more.
Gotta have my Pops."

But I digress. The reason I am writing is the new box art. It
seems to be a tie-in with the new film MISSION IMPOSSIBLE. And
yet, the layout, the colors, the fiery explosion, it all looks
a bit like the cover of DIANETICS. What does this mean? If I
buy this box will I have to buy increasingly more expensive
boxes until eventually I am told that Corn Pops was invented
by an alien deity after his expulsion from the cosmic
confederation? Will the local Scientologists begin handing out
free bowls of the stuff with those personality tests?

Please keep me posted,

Richard J. Mackin
1298 Comm. Ave #4
Allston MA 02134

27

July 25, 1996

Mr. Richard J. Mackin
#4
1298 Comm. Ave
Allston, MA 02134

Dear Mr. Mackin:

Thank you for writing Kellogg Company regarding the packaging and/or advertisement on packages of KELLOGG'S®CORN POPS®. We appreciate your interest in our products.

Kellogg Company's goal is to provide consumers with wholesome, high-quality products. One area of great importance is packaging. We continually evaluate our package designs to accommodate the needs of our many different consumers.

We regret the Ad synopsis "you ate the last bowl of Pops!?! ARRRGH! What am I gonna do? grunt grunt grunt. Oh, there's actually more. Gotta have my Pops." concerns you. Our packages are designed to illustrate taste appeal and we feel the print content gives consumers worthwhile information concerning our products and promotions. Therefore, your concern is important to us, and we have forwarded your comments to the appropriate company officials.

Again, thank you for contacting us. We hope you will be pleased with your Kellogg selection the next time you shop.

Sincerely,

Wanda F. Lindsey
Consumer Representative
Consumer Affairs Department

wfl/cl

1774581A

Kellogg Company / Corporate Headquarters
One Kellogg Square / P.O. Box 3599 / Battle Creek, Michigan 49016-3599 (616) 961-2000 Fax: (616) 961-6598

Dec 1, 1997

Dear Sorrento Cheese,

I just saw your ad featuring Father Guido Sarducci- a character
popularized on Saturday Night Live back in the 70's when it
was actually funny. As I am sure you know, the actor is a man
named Don Novello What you probably don't know is that Don also
went by the name Laszlo toth and wrote stupid letters to a bunch
of major corporations. Do you think that by featuring him, you
are endorsing this sort of behavior? What do you think about
those who partake in this sort of prank?

Please respond,

Rich Mackin
POBox 890
Allston MA 02134 **NO REPLY!**

Nov 15, 1996

Dear Texaco,

Despite the fact that I am writing to you on the same day that
the entire country is crying for your blood because you are
racist pigs, I am NOT writing about the fact that you are racist
pigs. I am writing because all this media attention has gotten
your logo into my field of vision WAY too much today, and I
noticed the major elements...

1)A RED circle

2)a STAR

3) the letter "T" in a bold unserifed font, so that it lokks
like a sledge HAMMER.

Put RED, STARs and a HAMMER together, and what do you get? Well,
add a sickle and you get Communist Propoganda. What's up with
that?

Please respond,

Richard J. Mackin **NO REPLY!**
1298 Commonwealth Ave #4
Allston MA 02134

June 1, 1997

Dear Discover Card,

I was watching TV and I saw your ad in which some lady is talking
about the things that she buys with your card, as if she would
never be able to buy things otherwise, and she mentions that
"SHOES ARE HER WEAKNESS"

Of course, Kryptonite is Superman's weakness, coming from the
planet Krypton, but living on Earth, Superman is effected our
yellow sun, which gives him these super powers. But the rock
from his home planet counteracts this effect, reducing his powers
and thus causing him grief and misery.

Please respond

Richard J. Mackin
1298 Commonwealth Ave #4
Allston MA 02134

NO REPLY!

Pepperage Farm June 20, 1997
595 Westport Ave
Norwalk, CT
06851-4413

Dear Pepperage Farm,

For ad long as I can remeber, the Pepperage Farms catchphrase
has always been...

"Pepperage Farm Remembers."

That's good. Those who forget the past are doomed to repeat
it (paraphrased.)

Please Reply,

Rich Mackin
1298 Commonwealth Ave #4
Allston MA
02134

NO REPLY!

30

Philadelphia Cream Cheese March 27, 2000
Kraft Foods
3 Lakes Drive
Northfield IL 60093

Dear Philadelphia Cream Cheese,

The other day I came home and found my roommate very disturbed, having just seen a commercial in which a pretty young female angel is sitting in heaven eating cream cheese and it says something about it being sinful, and so my roommate was for one concerned about the angel being cast out and into hell, what with the definition of sin meaning to break a covenant with God- the sort of thing that sends you to hell and all.

There was also some concern about the fact that the angel was so young. Since we don't know exactly what happens when a soul reaches heaven (assuming of course, that there is one) I am not sure if the angel is supposed to represent this woman when she died, but if it is, it is somewhat sad to think she died so young. "Why did she die?" I was asked.

Well, some time later, I saw this ad myself, and that is when I realized that it was for your product, Philadelphia Cream Cheese. It suddenly made sense to me, what that you are part of the Philip Morris family of products, and so perhaps your commercial is a hybrid of Judeo-Christian and Eastern reincarnation philosophies. Many Eastern religions teach that your actions affect your next life, so gluttons are reincarnated as pigs, etc; so maybe a similar concept follows with what happens in the more Western sense of afterlife- what you do in heaven reflects what you did while alive.

Are what you are trying to say is that those who die from Philip Morris products continue to consume Philip Morris products in the afterlife?

Please respond,

Rich Mackin
POBox 890
Allston MA 02134

P.S. Since you are called Philadelphia, wouldn't it be less morbid and religiously sketchy and more logical to have a live woman eating your products in that city instead of a cloud?

31

April 10, 2000

Mr. Rich Mackin
Post Office Box 890
Boston, MA 02134

Dear Mr. Mackin,

Thanks for getting in touch with us about advertising for our products. I'm glad you thought enough of us to share your comments.

We consider our advertising as our company's voice to the public and to consumers like you. It concerns us when one of our consumers expresses disappointment with an advertising campaign. With so many different audiences viewing our advertising and forming a wide range of opinions, it's hard to create advertising that makes everyone happy. For the most part, consumers reaction to our commercials and print advertising has been positive.

We always want to hear what you're thinking. Even though I can't promise we won't use this ad anymore, I want you to know I've shared your opinions with our marketing and advertising teams. Remember, food brings us together and together we can make something good!

Sincerely,

Kim McMiller
Consumer Resource Manager

7669548/9144391/KAC/kgf

KRAFT FOODS One Kraft Court Glenview, Illinois 60025 • (800) 323-0768
For Food & Family Ideas Visit Our Website at www.kraftanswers.com

1/31/00

Blue Cross
Blue Shield
Landmark Center
401 Park Drive
Boston MA 02215-3326

Dear Blue Cross/ Blue Shield.

I was at work today when my friend gave an envelope that caught my attention. It was yours, and it had the "Cost-saving bottom flap envelope". Of course, even if I didn't see the "Cost-saving bottom flap envelope", I would have noted it since itis printed right on said "Cost-saving bottom flap" that it is a "Cost-saving bottom flap envelope." I am intrigued. What makes this bottom flap so cost saving and what differentiates it from a normal envelope that you just turned upside down?

Rich Mackin
Post Office Box 890
Allston MA 02134

NO REPLY!

Jan 31, 2000

Dear General Mills,

For years, I have always found it amusing how with every new health fad, there is a Cheerios ad saying "We already knew that".

SODIUM IS BAD! "Hey, we never had that!"
SUGAR IS BAD! "Hey, we never had that!"
WHOLE GRAIN OATS ARE GOOD "Hey, guess what we are made out of!"
"FEEDING INFECTED MEAT TO COWS CAUSES MAD COW DISEASE" "Hey, no mad cows in Cheerios!"

And now there is this Genetic Engineered food thing. Um, you forgot you were the good guys. Please either ditch the frankenfood or label yourself (Cheerios, with free toy and untested genetic experiments inside!)

Rich Mackin
POBox 890
Allston MA 02134

NO REPLY!

Lever Company
800 Sylvan Ave
Englewood Cliffs, NJ

April 2, 2000

Dear Lever Brothers.

I was not WATCHING TV at the moment, but the TV was on. I was in the other room and I was walking in my living room just in time to hear, but not see, the end of one of your ads...

"For all your FAMILY'S 2000 parts."

Now the thing is, it used to be that Lever 2000 was for all my body's 2000 parts. So, if now it is for my Family's 2000 parts, how do explain the difference in parts of the human body. I mean, if we are talking about my mom, my sister, my stepfather and me, that is 4 people, with 500 parts, or at least an average of 500 each. BUT if you mean my entire family, grandparents, uncles aunts, cousins, etc, each person gets like about a hundred parts each. How big of a family are we talking here?

Another thing is that I don't live with my family any more. I live with a girl, and a cat. The cat does not use soap, so two people in my house would use the Lever 2000, so if we as a household is the considered family (Keep in mind that I missed the intro, so I can only guess your definition) we have 1000 parts each. But my Boss who lives with 3 kids, his wife and his dad, would have about 333 and a third parts. (How would they have a third of a part?)

What happened to the 2000 parts I once had?

Rich Mackin
POBox 890
Allston MA 02134

NO REPLY!

34

Philip Morris,
120 Park Ave
NYC, NY

Dear Philip Morris Tobacco Company,

Hello. My name is Bri, I am a smoker. I am nineteen. I can legally smoke in my
state, where the age of consent is 18 for tobacco purchasing.

I saw a TV ad put out by your company that has the caption
"Tobacco is Wacko, If You're a Teen."

I am troubled by this, since being nine-TEEN, I am still technically a teen, and so
for me, Tobacco is wacko until my next birthday. Why is it wacko for me now, but
not in a few months? What happens to chance this wackiness of tobacco? As a
teenager who is also an adult in terms of getting tried as one,and voting and taxes,
is tobacco less wacko for me as it is, say, my roommate who is seventeen? I
mean, she also smokes, but I don't see much difference between the wackiness of
my smoking and hers.

Is tobacco wacko for teens directly only, or is my second hand smoke wacko for
her? (And again, how wacko exactly for me?)

What exactly is wacko? I know what the word means, but what is wacko, exactly
about tobacco? The health problems? The addiction? The huge amount of money
 I spend on cigarettes? The fact that my apartment has dirty overflowing ash trays
(I won't go into who's responsible for them and doesn't clean after them...) I
guess one could call them wacko, I know I have a few non smoker friends that
says stuff like that. (Not the actual word wacko, but that TONE.) But aren't these
problems still there even for tried and true full blown adults?

Any explanation or free samples would be appreciated,

Bri Dellamano
31 St. Luke's Road
Apt 16
Allston, Ma 02134

Note that I helped a friend of mine write this, so I did write
it mostly, although it is not really on my own behalf.

PHILIP MORRIS

U.S.A.

120 PARK AVENUE, NEW YORK, N.Y. 10017 · TELEPHONE (917) 663-5000

April 20, 2000

Ms. Bri Dellamano
31 Saint Luke's Road #16
Allston, MA 02134

Dear Ms. Dellamano:

Thank you for contacting Philip Morris U.S.A.

Philip Morris does not want minors to smoke, nor do we want them to have access to tobacco products. We are committed to making a difference on this issue, and we have spent decades helping to prevent underage access to cigarettes.

As such, our marketing and other communications are intended for adults who choose to smoke -- and no one else. Accordingly, Philip Morris U.S.A policy precludes us from providing information about our cigarette products to anyone under the age of 21.

Sincerely,

John Barlow
Senior Consumer Affairs Specialist
Consumer Affairs

ID#: 1153872

MARLBORO BENSON & HEDGES MERIT VIRGINIA SLIMS PARLIAMENT PLAYERS SARATOGA CAMBRIDGE BASIC ALPINE

36

Jan 11, 2001

Coca Cola
P O drawer 1734
Atlanta GA 30301

Dear Coca Cola

I am doing a project about business and products and I was wondering if you could answer a question- how much is the actual Coke?

My point is that a can of coke costs 85 cents, a chilled bottle in a vending machine costs $1.25, but a two liter often costs only a buck on a grocery store shelf. Fountain coke at a restaurant or movie theatre always has more to do with where you buy it than how much you buy. So the price seems more reliant on placement, availability, storage, if it is refrigerated, etc.

So when I buy a dollar big bottle, a free-refill buck fifty glass at a Diner, an 85 cent can or a three dollar movie theatre cup, how much of my money actually went to the actual product, Coca Cola- the syrup and carbonated water beverage?

I hate to rush you, but it is for a project

Thank you

Andrea Kulish
101 Huntington Ave
19 Floor
Boston MA 02199

NO REPLY!

37

April 20, 2000
Willert Home Products
4044 Park St.
St. Louis MO 63110

Dear Moth ball people,

I have recently found out that cigarettes contain napthelene, the main ingredient in mothballs. I was thinking I might cut out the middle man. Do you have any smoking products? Or would you recommend me rolling my own mothball smokes?

Rich Mackin
PoBox 890
Allston MA 02134

WILLERT HOME PRODUCTS

10 August 2000

Mr. Rich Macklin
P.O. Box 890
Allston, MA 02134

Dear Mr. Macklin:

I am in receipt of your letter dated 20 April 2000. **It is a violation of Federal Law to use this product that is inconsistent with its labeling.**

We appreciate your letter explaining to us that you discovered that Tobacco Manufacturer's use the Naphthalene as an ingredient. However, we manufacture this product for the use of a moth preventive only. This is considered a hazardous material. You will need to contact the Tobacco Company regarding the ingredients and /or treatment procedures of their products.

The only item related to smoking that we manufacture, is ashtrays.

Thank you for your interest in our products. I'm sorry, but I am unable to assist you further at this time.

Best Regards,

Jean Longworth
Consumer Relations

Aug 1, 2001

Dear Chocolate Makers

I recently heard that the Chocolate Industry gets half it's cocoa from the Ivory Coast, where child slaves do most of the labor. This of course sucks, and I read this expecting to see the name Nestle' appear at any moment what that they suck and have been doing their best to suck Africa dry like the parasites they are.

But then I saw something that broke my heart.

"But the Chocolate Manufacturers Association (CMA), which includes Hershey and M&M/Mars, is mobilizing against any legislation (against child labor)"

The worst things I ever heard about Hershey is that Mr. Hershey used to get really mad when someone called a Hershey Chocolate Bar a "candy bar" and had delusions of the nutritional value of his products. The worst thing I have heard about M&Ms is that you they don't like to talk about the namesake of the 'M' who isn't Mr. Mars.

I am writing all of you to ask that you stop exploiting child slavery. I don't think I need to explain why child slavery is wrong. If I do, there is something seriously wrong besides the irony of poor little kids working to make wealthy little kids fatter. It reminds me how Disney forces poor third world kids with no money to buy toys to make toys for wealthy first world kids with too much money and toys.

I look forward to hearing your reply.

Rich Mackin
POBox 890
Allston MA 02134

CC:
Hershey
M&M/ Mars
Nestle'

Master*foods*USA.
A Mars, Incorporated Company
800 High Street • Hackettstown, NJ 07840

November 22, 2002

Mr. Rich Mackin
PO Box 890
Allston, MA 01234

Dear Mr. Mackin:

We would like to thank you for taking an interest in an issue that we in the chocolate industry have been working very hard to address. Child trafficking and abusive labor practices in the growing of cocoa are simply unacceptable to us at Masterfoods USA, A Mars, Incorporated Company. We strongly condemn these practices wherever they may occur. We believe that our products and their ingredients should be produced in a manner that is socially, environmentally and economically responsible.

We have worked with our colleagues in the chocolate industry, the U.S., European and West African governments, and other stakeholder organizations and advocacy groups to investigate and address any potential child trafficking or abusive labor conditions on cocoa farms in West Africa.

In 2001, our industry, with the support of government officials and third-party groups – undertook a global effort to make a real difference. We put together a comprehensive protocol that lays out a specific timetable to determine the extent of the problem, and to establish a system ensuring that cocoa is grown without abusive child labor or forced labor practices.

Most recently, the International Institute of Tropical Agriculture (IITA) released the results of a study required by the protocol to survey the current state of agricultural practices on West African cocoa farms. The survey, unprecedented in its scope, confirms the direction we have been taking. The study tells us that more than 99% of farmers in the Ivory Coast do not employ children as full-time workers. It has raised concerns about the use of children in potentially hazardous work in some portions of the cocoa-growing sector. We remain committed to promoting safe, responsible cocoa growing and to improving the well being of cocoa farming families

For more information about the specific steps in the protocol, please visit www.chocolateandcocoa.org.

As a matter of addressing the root causes of poor labor conditions, "Fair trade" is one of several options available – and the organizations behind it share our interest in improving the economic conditions of cocoa farmers.

Ultimately, however, fair trade is an approach that works best with farms that have access to infrastructure such as communications and warehousing facilities. While our long-term goals include encouraging the development of farmer organizations, currently the majority of farmers in West Africa do not have access to this level of infrastructure, and successful cocoa cooperatives are few and far between.

The steps we are currently taking to address cocoa growing conditions in West Africa are part of a broader effort initiated by Mars and the global chocolate industry in 1998 to improve the well-being of millions of responsible small farmers who grow cocoa worldwide. Our goal is to raise the standard of living of all farmers and their families who depend on cocoa for their livelihood.

We thank you for your concern and hope you will contact us if you have any additional questions.

Sincerely,

Gloria Vivenzio
Consumer Affairs
Masterfoods USA
A Mars, Incorporated Company

 I would like to point out that Hershey's also responded with a similar letter. It was much longer, and made much of the same points, so inclusion would be rather redundant. I do want to be fair and say that they did indeed respond.

August 3, 2000

Breath Savers
7 Campus Dr.
Parsippany, NJ 07054

Dear Breath Savers/ Philip Morris

I am writing to you because I am confused about your ads. Instead of advertising your mints like "Our candy tastes good" you have print ads that have sexy women breathing smoke that is being inhaled by sexy men.

And you just got bought by a tobacco company.

And tobacco companies make a smoky product that makes it hard to breathe, on one level in a room filled with smoke, and on another if you are a smoker in general, and yet your name is Breath SAVERS, which is ironic, because the thing that Breathing needs to be saved from is companies like Philip Morris.

Please reply,

Rich Mackin
POBox 890
Allston MA 02134

▼NABISCO

100 DeForest Avenue
P.O. Box 1911
East Hanover, NJ 07936-1911
1-800-NABISCO

September 13, 2000

||l....l.l...ll..ll..l..l.lll..l

Mr. Rich Mackin 8536635-01
P.O. Box 890
Allston MA 02134-0006

Dear Mr. Mackin:

Thank you for contacting us regarding Nabisco's advertising campaign for BREATH SAVERS COOL BLASTS. Consumer opinion is very important to us.

We make every effort to see that all of our advertising messages are prepared and carried out with high quality and good taste in mind. Therefore, your comments are valuable to us and have been brought to the attention of our advertising personnel.

Thanks for taking the time out of your busy day to let us know how you feel.

Sincerely,

Amanda L. Hosmer, R.D.

Amanda L. Hosmer, R.D.
Team Leader
Consumer Affairs

41

Frugal Fannie's Sept 12, 2000
380 Western Ave
Brighton MA 02135

Dear Frugal Fannies,

I sit here contemplating your postcard sent to me with the caption

"Calm down, Ms. Mackin... it's just the boys from the male political establishment
trying to capture the elusive women's vote."

...which is underneath a cartoon of biplanes circling King Kong atop the Empire State
building. I am not sure what confuses and offends me more, the link to our elected
officials as outdated assailants, the comparison with women voters to a large kidnapping
ape, or your blatant assault on my masculinity.

Rich Mackin
POBox 890
Allston MA 02134

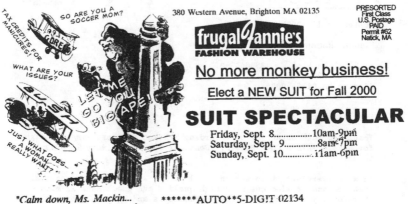

380 Western Avenue, Brighton MA 02135

PRESORTED
First Class
U.S. Postage
PAID
Permit #62
Natick, MA

frugal fannie's
FASHION WAREHOUSE

No more monkey business!

Elect a NEW SUIT for Fall 2000

SUIT SPECTACULAR
Friday, Sept. 8................10am-9pm
Saturday, Sept. 9..............8am-7pm
Sunday, Sept. 10............11am-6pm

*******AUTO**5-DIGIT 02134
Ms. Mackin

Allston, MA 02134-2922

"Calm down, Ms. Mackin...
it's just the boys from the male
political establishment trying to
capture the elusive women's vote."

Frugal Fannie's							10/10/00
380 Western Ave
Brighton MA 02135

Deal Frugal Fannie,

Please, For the Love of GOD, Stop writing to me and referring to me as "MS." It's not funny. I don't know whether you think you're funny or what, but you're not. Let me say that your attack on my masculinity is not only unfounded, but poorly constructed. I know several transgendered individuals who are fully functioning members of society, so I don't even take it as an insult.

Still, you are wrong. I am not a woman. I am a heterosexual man. There is no more need to call me "Ms." than there would be to address me as "Big Rugby Fan" or "Tall thin African American" or even "Monsignor Mackin, Phd." Although I do like that last one.

Actually, If you insist on a title, how about "Lord"?

Lord Mackin
1197 Commonwealth Ave
Apt 3
Allston MA 02134

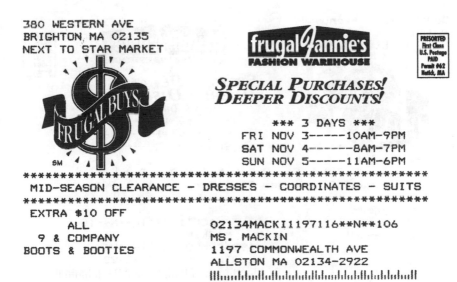

380 WESTERN AVE
BRIGHTON, MA 02135
NEXT TO STAR MARKET

frugal annie's
FASHION WAREHOUSE

PRESORTED
First Class
U.S. Postage
PAID
Permit #62
Natick, MA

SPECIAL PURCHASES!
DEEPER DISCOUNTS!

*** 3 DAYS ***
FRI NOV 3------10AM-9PM
SAT NOV 4-------8AM-7PM
SUN NOV 5------11AM-6PM

MID-SEASON CLEARANCE - DRESSES - COORDINATES - SUITS

EXTRA $10 OFF
 ALL
9 & COMPANY
BOOTS & BOOTIES

02134MACKI1197116**N**106
MS. MACKIN
1197 COMMONWEALTH AVE
ALLSTON MA 02134-2922

Nov 3, 2000

Frugal Fannie's
380 Western Ave
Brighton MA 02135

Dear Frugal Fannie

I have written to you twice now telling you that I am not MS Mackin, that there is no Ms Mackin living at this address. And yet you keep sending me mail addressed to Ms. Mackin.

What are you trying to say? Are you implying that there is someone living here that I am related to, either by blood or marriage and that I am lying to you? Are you implying that there is a relative that I don't even know about that I live with? Well, I have news for you, if there is, she ain't getting her mail, so you better stop writing!

MR, as in man, Mackin
1197 Commonwealth Ave
Allston MA 02134

380 Western Avenue
Brighton MA 02135
Next to Star Market

SM

FASHION WAREHOUSE

PRESORTED
First Class
U.S. Postage
PAID
Permit #62
Natick, MA

SPECIAL PURCHASES!
DEEPER DISCOUNTS!
3 Days Only!
Fri Nov 10----10AM-9PM
Sat Nov 11------8AM-7PM
Sun Nov 12----11AM-6PM

V E T E R A N S W E E K E N D S A L E
>>> Many Timely New Coat Markdowns!!! <<<

Our Biggest
Coat Event
of the Season!

02134MACKI1197116**N**104
MS. MACKIN
1197 COMMONWEALTH AVE
ALLSTON MA 02134-2922

Nov 19

Frugal Fannie's
380 Wesstern Ave
Brighton MA 02135

Dear Frugal Fannie's

I am tardy in my weekly complaint about your weekly attempt to affront my masculinity
because I was in Washington DC, at the Vietnam and Korean War monuments for
Veteran's Day. I realize that this is not as good a way to honor our veterans than by
having the "Biggest Coat Event of the Season" with "Deeper Discounts" but what can I
do, I am only one man (despite your insinuations to the contrary.)

MR. Mackin
1197 Commonwealth Avenue
Allston MA 02134

380 Western Ave
Brighton MA 02135
Next to Star Market

frugal fannie's
FASHION WAREHOUSE

PRESORTED
First Class
U.S. Postage
PAID
Permit #62
Natick, MA

save BIG BUCKS Sale!

Starting this FRIDAY Dec 1
NOW OPEN EVERYDAY
til Christmas
FRI-SAT-SUN-MON-TUE-WED-THUR
www.frugalfannies.com

Fri 10-9, Sat 8-7, Sun 11-6 ***** Mon-Tue-Wed-Thu 10-7

GREAT GIFTS!
For every lucky
woman on your
list...even for
yourself!

02134MACKI1197116**N**96
MS. MACKIN
1197 COMMONWEALTH AVE
ALLSTON MA 02134-2922

Dec 8

Frugal Fannie's
380 Wesstern Ave
Brighton MA 02135

Dear Frugal Fannie's

Another week, another attempt to mock my sexuality.

Damn you. Damn your black heart Frugal Fannie.

MR. Mackin
1197 Commonwealth Avenue
Allston MA 02134

380 WESTERN AVE
BRIGHTON MA 02135
NEXT TO STAR MARKET

frugal Fannie's
FASHION WAREHOUSE

PRESORTED
First Class
U.S. Postage
PAID
Permit #62
Natick MA

BUY-OUT

SM
NEW SHIPMENTS!

Manufacturer's Close-Out SALE!
*** 3 DAYS! ***
FRI DEC 29----10AM-9PM
SAT DEC 30-----8AM-7PM
SUN DEC 31---11AM-5PM
MON JAN 1-----9AM-6PM
**
 B A C K B Y P O P U L A R D E M A N D
**
 "MALL STORE"
 MANIA
$5.00 TO $15.00
 EACH PIECE

02134MACKI1197116**N**88
MS. MACKIN
1197 COMMONWEALTH AVE
ALLSTON MA 02134-2922

Dec 14, 2000

Dear Frugal Fannie's

I have resigned myself to getting your junk mail and it's weekly affront to my maleness. At least now you merely call me a woman without making cryptic references to gorillas or my voting habits.

Anyway, since it is apparent that this mailing relationship will be going on for quite some time, like it or not, I enclose a coupon from a local pet store for a free goldfish. Use the goldfish wisely. Note that the coupon is for a "common" goldfish. Please do not attempt to use it for a fancy pants goldfish. I think it is enough for me to try and make peace with you people by giving you any coupon for any fish, without you trying to overstep your boundary by wanting special fish. I mean, you started this whole thing, I never said that Frugal Fannie was a man, did I?

Rich Mackin
1197 Commonwealth Ave #3
Allston MA 02134

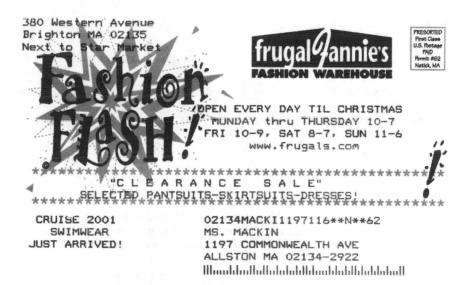

380 Western Avenue
Brighton MA 02135
Next to Star Market

frugal annie's
FASHION WAREHOUSE

PRESORTED
First Class
U.S. Postage
PAID
Permit #62
Natick, MA

OPEN EVERY DAY TIL CHRISTMAS
MONDAY thru THURSDAY 10-7
FRI 10-9, SAT 8-7, SUN 11-6
www.frugals.com

"C L E A R A N C E S A L E"
SELECTED PANTSUITS-SKIRTSUITS-DRESSES!

CRUISE 2001
SWIMWEAR
JUST ARRIVED!

02134MACKI1197116**N**62
MS. MACKIN
1197 COMMONWEALTH AVE
ALLSTON MA 02134-2922

Dear Pepsi one

I was watching Tv and there is this ad and all these people are sitting next to each
other and half of them have cokes and half of them have Pepsi Ones and it is like one
person drinks one soda and the person sitting next to them drinks the other and then
the next drinks the first, except that they drink one, and then the next, like they keep
switching and nobody notices that they aren't drinking the same thing, they are drinking
two different things and I guess the point is that Pepsi One is supposed to taste like a
regular soda, but shouln't it taste like Pepsi and not Coke?

I mean, like, for you to say that Pepsi One tastes good like Coke means that I want to drink
Coke, or something that tastes like Coke, right? So like, now I want a Coke because I
watched a Pepsi ad. Weird.

Rich Mackin
POB 890
Allston MA 02134

NO REPLY!

Oct 6, 2000

Ecreative search
218 N. Jefferson
suite 100
Chicago, Il, 60661

Dear Ecreative search,

For some reason, you sent me a yo-yo with a card asking

"Have you taken us for a SPIN lately?"

I get it.

Anyway, I am a collector of premiums and such and have to say that you are far from the
first company to attempt to cue my favor with a yo-yo. The problem is that I have
received far better quality yo-yos in the past, and so can only associate your company
with the sub par. All I know about you is that even your gimmick is half assed. You lose.

Rich Mackin
POBox 890
Allston MA 02134

NO REPLY!

48

Nov 6, 2000

Hills Pet Nutrition Inc
PO Box 410326
Kansas city MO
64179-9715

Dear Hills Pet Nutrition,

I received a flier in the mail from you, addressed to me by name, claiming to be "A free offer for my cat."

I didn't know I had a cat.

Rich Mackin
POBox 890
Allston MA 02134

NO REPLY!

Oct 6, 2000

Dear General Mills,

I have been very sick lately and spent about 2 days on my couch passing in and out of consciousness while watching Tv in a fever induced state of semi-hallucination.

At one point I had a dream that was like a commercial, it was for a product that was a bowls' worth of cereal compressed into a bar, but it had milk in it. The milk was unnaturally bright white, and scarier still- SOLID. Solid milk, how nasty that must be!

I just thought you would be interested in hearing about this. Obviously, no company would want any part of a gimmick this disgusting and bizarre and just plain wrong in real life.

Thanks,

Rich Mackin
POBox 890
Allston MA 02134

49

General Mills Consumer Services

P.O. Box 1113, Minneapolis, MN 55440

November 6, 2000

Mr. Rich Mackin
Box 890
Allston, MA 02134

Dear Mr. Mackin:

Thank you for contacting General Mills regarding Chex Milk N Cereal. We appreciate the time you have taken to share your comments. The information you provided will be carefully reviewed with other members of the product team.

We hope you continue to enjoy the products and services offered by General Mills.

Sincerely,

Jennifer Sherman

18 December 2000

HO HO HO! And a Merry Christmas! Happy Holidays!

Santa here. Funny thing happened this week. I was doing some toy research on fashionable Newbury Street in Boston, Massachusetts and a nice young lad handed me a flier talking about sweatshops in Saipan, a U.S. Territory located in the Pacific Ocean. It seems all of you use these sweatshops to manufacture items for your companies.

I regret to inform you that this puts you on my NAUGHTY list. Even after I checked it twice.

No toys for you this year, just a lump of coal. Next year, fair trade will get you presents under the tree.

Sincerely

SANTA CLAUS
Boston North Pole Satellite offices
POBox 890
Allston MA 02134

Cc:
J.C. Penney
6501 Legacy Dr.
Plano, TX 75024

Lane Bryant
Five Limited Parkway east
Reynoldsburg, OH 43068

The Limited
Three Limited Parkway
Columbus, OH 43068

OshKosh B'Gosh
112 Otter Ave
Oshkosh, WI 54901

Sears Roebuck
3333 Beverly Rd.
Hoffman Estates, IL 60179

Wal Mart
702 Southwest 8th St
Bentonville, AR 72716

GAP, Inc.
900 Cherry Ave.
San Bruno, CA 94066

I sent this to all these places (and modified versions to others) accompanied by actual lumps of coal.

WAL★MART

WAL★MART STORES, INC. LEGAL TEAM
702 S.W. 8TH STREET
BENTONVILLE, AR 72716-8095
PHONE: 501-273-4505
FAX: 501-277-5991

ALLISON D. GARRETT
Vice President and Assistant General Counsel

January 18, 2001

Santa Claus
P.O. Box 890
Allston, MA 02134

Dear Santa:

We received your letter and your "gift" after Christmas but we wanted to set the record straight so that we may change our status from your "naughty" list to your "nice" list.

Let me assure you that Wal-Mart shares your concern, and therefore, has developed Standards for Vendors. Vendors are required to adhere to this policy in order to do business with Wal-Mart. We audit the factories our vendors use to assure compliance with these standards.

Regarding Saipan, Wal-Mart has had a policy in place for several years of not sourcing merchandise from Saipan.

We recognize your wonderful track record for working with children. Wal-Mart has strived to follow your great example. Among our accomplishments are:

- $160 million in 12 years to the Children's Miracle Network
- $144 million in 16 years to the United Way Foundation
- In 1998, Wal-Mart was presented the National Missing Children Award by the National Center for Missing and Exploited Children

Thank you again. We hope that we have adequately shown our record of strong standards for our vendors as well as community support and involvement. Maybe next year we can look forward to something other than coal. And by the way, if your elves are unable meet the miraculous demand for toys for all of the children in the world, Wal-Mart will always be eager to help.

Sincerely,

Allison Garrett
Vice President and Assistant General Counsel

52

Mar 7, 2001

Allison Garrett
Vice President and Assistant General Counsel
Wal-Mart
702 SW 8th St
Bentonville AR 72716-8095

Dear Wal-Mart,

I am writing because it's ironic that you are using Zorro in your ads. As I am sure you don't know, the character Zorro was the hero of the poor laborers who helped them stand up against evil landowners. As a company that runs sweatshops abroad and wrecks havoc here because of your predatory business practices, I would think that someone that stands up for the little guy is someone your company would hate.

"Now wait!" You say, I am sure you will, "We don't use sweatshops!" will say the letter you write me in reaction. (I almost said form letter, but to your credit, my last letter from Wal Mart was very personal) But there was an article in the February 2001 issue of the Progressive by Congressman Sherrod Brown that discussed Cristina Sanchez who "worked for Chentex, a sweatshop…"where she "was getting paid twenty cents for every pair of jeans she produced. Americans buy them at Kohl's and Wal Mart for $25."

Are you going to call Congressman Brown a liar?

Rich Mackin
PoBox 890
Allston, MA 02134

P.S. Robin Hood would also be a poor character for you to use, however, there are many characters in the work of Charles Dickens you might consider.

CC: Congressman Sherrod Brown
2438 Rayburn House Office Building
Washington, DC 20515

Mr. Maelwi -

 Great letter to Wal·Mart!

Keep it up.

 Sherrod Brown

Jan 11, 2001

Frito-Lay Address
7701 Legacy Drive
Plano, TX
75024-4099

Dear Tostitos.

While watching TV and seeing something about Mosquitoes, I started thing about
how Mosquitoes sounds like a chip a la Doritos or Tostitos, and then I started
thing about how mesquite is like a Tex Mex flavor like you have in Doritos or
Tostitos, so maybe you could have Mosquitos be the chip with a bug mascot and
a mesquite flavor.

When I went to your web page <http://www.fritolay.com/contact.html> to get your
address, I noticed that you had a picture of a girl on it. I first saw this picture in
the ONION article "Totally Hot Chick Also Way Psycho" and then in a few dating
service and similar ads in the back of the weekly newspaper. What is her deal?

Please respond,

Rich Mackin
POBox 890
Allston MA 02134

55

 Frito-Lay, Inc.

February 1, 2001

Mr Rich Mackin
P O Box 890
Boston, MA 02134

Dear Mr Mackin:

Thank you for your letter suggesting your idea for a new product to Frito-Lay. We are flattered to hear from our consumers, but are disappointed that we are unable to accept your suggestion.

We appreciate your comments about the actress featured on our web site. Talent selected for product photo shoots is selected by an ad agency and not intended to offend any one. We apologize and will do a better job in screening talent in the future. We have forwarded your comments to our advertising agency.

We do appreciate your taking the time to bring your view point to our attention, as it is only when our consumers respond that we are made aware of unanticipated reactions to our advertising.

Thank you again for taking the time to contact us. Please accept the enclosed coupon for the Frito-Lay product of your choice. Should you have additional questions or comments, please call us toll free at 1-800-352-4477 Monday through Friday between 9:00 a.m. and 4:30 p.m. Central Standard Time or e-mail us at consumer.affairs@fritolay.com.

Sincerely,
Consumer Affairs

Enclosure: 1 Consumer's Suggestion Letter
 1 Free Product Coupon

35424540

2/15/01

Bill Medley
Righteous Brothers
9841 Hot Springs Drive
Huntington Beach, California 92646

Dear the Righteous Brothers

We all know that the most played song in the history of American radio is
"You've Lost That Lovin' Feeling" by the Righteous Brothers.

We all know that the first line of this is
"You never close you eyes any more when I kiss your lips."

But the thing is, how does he know that she doesn't close her eyes if he didn't keep his
own eyes open to see if she keeps hers open. I mean, for one, maybe that is why she is
doing it, to see if he never closes his eyes either. For two, he's kinda being a hypocrite
then by making such a big deal about it.

Maybe if these two(in the song, not the righteous Brothers) would communicate to each
other more instead of writing songs about their problems to sing to others, they would
be happier.

Rich Mackin
POBox 890
Allston MA 02134

NO REPLY!

57

Mar 7, 2001

Dear Skittles

For some time now, you have had a campaign based on this "taste the rainbow" theme and raining skittles. Wouldn't small hard objects dropped from such a high distance hurt and cause considerable damage.

And once again, here is an ad campaign that instead of having the message be "buy our product" it's "Do a weird arcane ritual in some exotic locale and Skittles will fall on
you." Wouldn't something that focuses on how skittles can be bought be more in tune with your goals?

Rich Mackin
PO Box 890
Allston MA 02134

NO REPLY!

March 14, 2001

Westminster Cracker Company
8 Randbury Road
Rutland Vermont, 05701

Dear Westminster Cracker Company

Last night I was in Delihaus, a Diner like restaurant in Kenmore Square, Boston. I ordered the black bean chili, a personal favorite. As restaurants often do, they provided me not only with a brimming bowl of tasty chili, but a few small bags of crackers-namely your "Old Fashion Oyster Crackers."

I am wondering why these are called Oyster Crackers, but more importantly, why they are called Old Fashion? Are there new fashion crackers? What's the difference?

Rich Mackin
POBox 890
Allston MA 02134

NO REPLY!

March 2, 2001

Governor Bob Taft
30th Floor
77 South High Street
Columbus, Ohio 43215-6117

Dear Governor Taft.

I am writing to you because I am concerned about Ohio laws: I do a spoken word/ reading tour every year and travel through Ohio annually as a result. I normally have a good time, but I am worried about coming into the state this year: having read about DJ and Carlotta Maurer. These two teenagers were arrested because they refused to watch the advertising filled "Channel One" which is shown in schools in lieu of trying to teach them.

Gov. Taft, while I do enjoy watching TV at home on occasion, I usually have a very tight schedule while travelling, and doubt that I will be able to watch any TV while in your state. However, I do not wish to cause a disturbance, nor do I wish to get arrested, and so I was wondering if there is some sort of "Diplomatic immunity" I could get as an out of state traveler. How would I apply for some sort of document that would keep me from getting arrested if caught not watching TV.

Can you please send me a copy of the actual law that require TV watching. As I said, I don't wish to cause any trouble, and would like to follow both the letter and spirit of the law.

Thank You,

Rich Mackin
POBox 890
Allston MA 02134

NO REPLY!

3/2/01

Dear Virginia

I just read in the Feb 26 edition of US News and World Report that you are working on Legislation to post "In God We Trust" signs in schools, allow people to carry concealed weapons in bars (I guess we don't trust God THAT much, since we need backup) and make it illegal to sleep anywhere but the bedroom of your own home.

Well, it is the new millennium, and many people are choosing this as a time for change. I guess I will soon be seeing "Virginia is for Lovers" replaced with "Virginia is for Unamerican Right-wing Crackpots." Boy, what a bumper sticker THAT will make.

Please respond,

Rich Mackin
POBox 890
Allston MA 02134

CC:
Gov. James Gilmore III
State Capitol, 3rd Floor
Richmond, Virginia 23219

Lt. Gov. John Hager
900 E. Main Street, Suite 1400
Richmond, VA 23219

Virginia Tourism Corporation
901 E. Byrd St.
Richmond, VA 23219

NO REPLY!

5/18/01

Dear Mr. Schindler,

I am writing to you about your company's targeting of gay and homeless people in San Francisco. Your company called this Project SCUM. Now, while I certainly understand your company's link to scum, I find it ironic that you link this specific campaign to scum. Perhaps you should just call your marketing and sales staff Project SCUM from now on, and all will be clear.

I have decided you might be interested in having me point out the holes in your letter of apology to the San Francisco Weekly. Your words are in quotes...

"An apology from RJR Tobacco: I became aware of a wholly unacceptable and offensive document that existed in the files of employees of this company through your story "Smoking Gun" ..."

Wait, you need to read the newspapers about what goes on in your own company? Not a very good way to run the ship there Andy.

"The document was created in one of our sales offices, and we are investigating who wrote it, and who might have seen it within the company."

Wait, you are investigating it? Now? Just now? Wasn't this from the mid 90's? Shouldn't you have already found out about it, investigated it, and brought 'Appropriate disciplinary action... against those individuals'? If you are just getting around to it now, I don't know, it seems a bit coincidental and somewhat reeks of being a last minute half-assed attempt at PR damage control

"Appropriate disciplinary action will be taken against those individuals because the document is antithetical to how we operate this company."

Please regale me with a description of appropriate discipline. Do you mean they will be fired? Or just told to be more careful about how they say stuff? I mean, are they in trouble for what they did, or for getting caught?

"RJ Reynolds Tobacco Co. respects all of its customers and greatly values their business."

Which is why you sell a product that, when used correctly, can kill them.

"We operate this company ethically and responsibly."

HAHAHA! No, really, that's funny. Explain the ethical way to make money off of causing cancer.

Mr. Schindler, I look forward to your detailed response, privately or publicly.

Richard Mackin
POBox 890
Allston MA 02134

NO REPLY!

Sent to the CEO of RJ Reynolds Tobacco

March 14, 2001

Memorial Sloan-Kettering Cancer Center
Box E, 1275 York Avenue
New York, NY 10021

Dear Memorial Sloan-Kettering Cancer Center

I am writing to you because I would like to send you a donation. But before I make this donation, I would like you to ask your Board of Directors Member, John Reed, to write me a personal letter of thanks in anticipation. In it, I would like him to explain how he can in good conscience serve on the Board of Directors of both a Cancer Treatment Center and a Cancer Causing Center, namely Philip Morris.

Philip Morris, as you know, is the largest manufacturer of a product that when used as directed causes colorectal, lung, mouth, pharnyx, larynx, esophagus, pancreas, kidney and bladder cancer.

I look forward to reading Mr. Reed's letter.

Rich Mackin
POBox 890
Allston MA 02134

NO REPLY!

March 15, 2001

Dusty Kidd
Global Director for Labor Practices
Nike Corporation
One Bowerman Drive
Beaverton, OR 97003

In response to a British demonstration at a Niketown, Phil Knight has said that the demonstrators should talk to Nike instead of disrupting shoppers. But when renown activist Jim Keady tried, well, the conversation went like this...

Phil Knight: "You need to talk to Dusty Kidd."

Jim Keady: "But he doesn't want to talk to me."

Phil Knight: "Well, then I guess you don't get through then."

So, people that don't like how you guys use sweatshop labor shouldn't disrupt shoppers, according to Knight (of course, if Nike was a fairly run company, nobody would feel the need to disrupt shoppers) but he won't talk to people, you don't want to talk to people. Are you just saying that you like sweatshops so much you refuse to hear any criticism?

Why not make an ad that has Phil with his hands over his ears saying "NYAH NYAH I'M NOT LISTENING!" and maybe come up with a new tagline about how you chose to use sweatshops, whether or not that makes you popular. This will make you seem rebellious and cool.

Please respond,

Rich Mackin
POBox 890
Allston MA 02134

nike

April 2, 2001

Rick Mackin
PO Box 890
Allston, MA 02134

Dear Rick Mackin:

Please rest assured that Nike has nothing to hide. We have taken significant actions to improve the lives, opportunities, and working conditions of the people who make our products around the world. Our success as a company is based on fulfilling our responsibilities to the people who make our products; the communities where our products are made, sold and bought; the environment and natural resources that allow us to be successful; and the consumers who depend on our product excellence.

Nike unequivocally condemns child labor and our Code of Conduct specifically prohibits it. We have some of the toughest age standards in our industry. As specified in the Code, no workers under the age of 18 are allowed to work in factories that produce Nike footwear and no workers under the age of 16 are allowed to work in factories where other Nike products are made. We regularly monitor our partner factories to ensure they comply with these standards.

Nike understands the need to meet basic worker requirements by providing fair wages. The fact is Nike offers good wages, benefits and desirable jobs in countries where wages are low and jobs are scarce. We start by using country-mandated minimum wages as a foundation. In most cases however, entry- level workers earn more in cash and allowances than local governments require. In addition to wages, most workers also receive benefits such as housing, transportation, on-site health care and meals. Jobs in Nike contract facilities provide opportunities to build a lifestyle and life skills that are not typically available in other wage earning opportunities in the areas where our products are manufactured.

We have zero tolerance for abuse and harassment of workers. Our Code of Conduct specifically prohibits it. To achieve compliance with our Code and working standards, Nike labor practices managers educate and train factory partners. If factories are found in violation of the Code, we work with factory managers to encourage change and compliance. If violations continue however, Nike terminates its contract with these manufacturers. We have terminated ten contracts in the past two years but use this measure only as a last resort.

Nike also has some of the most comprehensive and independent labor-monitoring programs of any company in the world. We are involved in numerous monitoring systems – both internal and external. PricewaterhouseCoopers monitors every factory where Nike products are made every year to assess factory conditions. Additionally, internal SHAPE (Safety, Health, Attitude of management, People and Environment) audits measure factory improvements and compliance with Nike's standards. But it doesn't stop there. We are also part of the Global Alliance for Workers and Communities. This is a private, public and nonprofit collaboration that uses worker-driven evaluations to improve the workplace and living conditions of young adults involved with global manufacturing.

In terms of the Fair Labor Association (FLA), Nike will continue to support the organization because it enables activist, labor, consumer, university and manufacturing groups to work together to initiate change and establish protection for workers worldwide. This partnership has resulted in the creation of a single Code of Conduct that everyone can follow, and adjust, as needed. We strongly believe it is impossible to solve these complex issues without the input of those in a position to actually make change happen – the manufacturers and factory owners – sitting alongside consumer and human rights groups, trade unions and universities.

At Nike we know that globalization and human rights can – and do – co-exist. That's why we work closely with non-profit organizations, governmental authorities, and other partners to ensure that our workers, and their communities, benefit from their relationship with Nike. Please visit our website at www.nikebiz.com for more details and the most current information about Nike's corporate responsibility programs.

Sincerely,

Cheryl McCants
Corporate Responsibility Manager
Nike, Inc.

64

March 15, 2001

McDonald's
McDonald's Plaza
Oak Brook, Illinois 60521

Dear McDonald's

AS I understand it, the appeal of McDonald's isn't taste or quality or nutrition, but constancy. I don't go to a McDonald's thinking I am going to have a good meal, but at least I know I am eating the same thing at a McDonald's in Ohio as I would in New York City.

Or am I?

It seems you have decided to stop selling genetically engineered food to Europeans, going so far to not even use GE feed to your livestock, but have no problem feeding us Americans frankenfood. Aren't you an American company? Why show preference to others, while forsaking the place that your friends and family live?

Rich Mackin
POBox 890
Allston MA 02134

McDonald's Corporation
McDonald's Plaza
Oak Brook, Illinois 60523-1900
Direct Dial Number

(630) 623-6198

March 19, 2001

Mr. Rich Mackin
PO Box 890
Allston, MA 02134-0006

Dear Mr. Mackin:

Thank you for your interest in McDonald's food products. We appreciate this opportunity to respond to your questions.

First, you should know the safety of our customers is our top priority. Although we don't normally own our food suppliers, as a purchaser of food products, we absolutely require our suppliers to meet or exceed all government regulations.

The issue of biotechnology for food and animal feed is a complex subject that reaches far beyond the entire retail and restaurant industry, including McDonald's. That is why we all must continue to rely on the leadership and guidance of scientific experts and official international and domestic regulatory agencies and authorities, such as the U.S. Department of Agriculture, the Food and Drug Administration, European Union authorities, the World Health Organization, and the United Nations Food and Agricultural Organization. According to scientific research, these experts state that genetically modified ingredients in feed have no effect on the quality or safety of meat, milk or eggs. This conclusion has been reinforced by a review of worldwide data conducted by the Federation of Animal Science Societies.

However, McDonald's listens carefully to our customers and considers the marketplace in our decision-making. Maintaining the confidence of our customers is always our top priority. If there are individual marketplace concerns with what kind of grain farmers feed their animals, we take these into consideration. As you know, regardless of the research, there is a general lack of acceptance in the many European marketplaces, so McDonald's Europe has directed their suppliers to use non-GM feed for poultry. It is important to note that this is not a statement about the technology itself, but rather a decision based on marketplace acceptance.

Again, this is an issue that goes beyond our suppliers, and McDonald's, which is why it belongs in the hands of the real experts. We will continue to monitor research as it pertains to this area.

Thank you again for taking the time to contact McDonald's. We would appreciate having the opportunity of serving you soon.

Sincerely,

Sara Ericksen

Sara Ericksen
Representative
Home Office Customer Satisfaction Department

66

July 11, 2001

Exxon/ Exxon Mobil/ Esso/ Whoever you are
5959 Las Colinas Blvd
Irving TX 75039

I was just thinking about my unanswered letter to you and your dunce of a spokesperson, Tom Cirigliano in which I asked about his statements such as their being trouble in the Middle East and that we should save real tigers (Instead of having lawsuits about cartoon ones brought against you by Tony and Kellogg's)

Well, I haven't heard anything about you guys trying to save any real tigers, and in fact, since you guys seem to be having such a negative effect on the environment- you are actually helping to kill them off, too.

As the world's largest Oil Company and thus major purveyor of fossil fuels, ExxonMobil or whatever name you call yourself today has "tremendous influence over climate change" (so says one of the many anti- you web sites I have seen.)

Tom was so intent on making a point that there are worse atrocities in the world than copyright infringement that I would like to bring up some more examples of bad things worse than cartoon tiger use.

1) A major Oil Company is being accused of encouraging human rights abuse by security forces used to protect its gas field in Aceh, Indonesia.
2) The same Company stands accused of knowingly allowing MTBE to pollute Long Island's drinking water.
3) Something about the Alaskan Coastline and drunk sea captains.
4) The SAME COMPANY wants to drill for oil in the Arctic National Wildlife Refuge and the Front Range of the Rocky Mountains.

There's 4 things right there that are worse than copyright infringement. Maybe you can call Kellogg's and put asides your differences and stop them all.

Please actually write me back this time. Not writing back is like saying you don't care. Which is possible since

"(You) know (you) have a giant target painted on (y)our chests." According to Ken Cohen, ExxonMobil's head of governmental relations, on 4/17/2001.

Rich Mackin
POBox 890
Allston MA 02134

NO REPLY!

67

May 16, 2002

Chiquita Brands International
250 East Fifth Street
Cincinnati, OH 45202

Dear Chiquita
Here is a haiku

"The worlds most perfect food"
Will you get nutrition, or…
Slip and fall on peel?

Please respond,

Rich Mackin
POBox 890
Allston MA 02134

NO REPLY!

Dear Gulden's Mustard

Here is a haiku.

Due to the color
I thought your name was GOLDen's
Still not sure I'm wrong.

Enjoy,

Rich Mackin
POBox 890
Allston MA 02134

NO REPLY!

Dear Edge Gel

Here is a haiku.

Small amount in hand
Far surpasses shaving cream
Many thanks, edge gel

Enjoy,

Rich Mackin
POBox 890
Allston MA 02134

NO REPLY!

Dear Wonder Bread

Here is a haiku.

Culture Metaphor
Uniform, sliced, bleached, in bag.
Builds bodies twelve ways

Enjoy,

Rich Mackin
POBox 890
Allston MA 02134

NO REPLY!

May 16, 2002

Dear Altria

The PR spokesperson has said
"Philip Morris fills people with dread,
Altria's the new name,
Policy is the same,
Our products still help make you dead."

Please respond,

Rich Mackin
POBox 890
Allston MA 02134

NO REPLY!

May 16, 2002

Dear Oreo cookies

Here is a limerick

A cookie we call Oreo
Baked by our friends at Nabisco
Since its been around
White stuff sandwiched in brown
Whats the "stuff" in the middle? Dunno.

Please respond,

Rich Mackin
POBox 890
Allston MA 02134

NO REPLY!

May 16, 2002

Dear Gap

Here is a limerick

I went to go buy stuff at Gap
But was threatened by friends with a slap
They said "you better stop!"
"That place uses sweatshops
to make all their overpriced crap!"

Please respond,

Rich Mackin
POBox 890
Allston MA 02134

June 19, 2002

Mr. Rich Mackin
PO Box 890
Allston, MA 02134

Dear Mr. Mackin:

Thank you for your letter and the opportunity to provide you with
the following information about our sourcing practices.

How we operate reflects our values, beliefs and business ethics.
Since many people are interested in learning more about our
sourcing practices and global compliance efforts, we have
developed a section on our corporate Web site that gives a broad
range of information surrounding this topic. Please visit the Social
Responsibility section on gapinc.com, and click on Ethical
Sourcing for more information.

Sincerely,

Gap Inc.
Global Compliance

Dear Gillette

Here is are some haiku.

The best ✦man can get?
Inner peace and happiness.
Far more than just ✦ shave.

5 O'clock shadow
returning again: unlike
blind bunnies' sight.

Enjoy,

Rich Mackin
POBox 890
Allston MA 02134

 The Gillette Company

World-Class Brands, Products, People

PO Box 61
Boston, Massachusetts 02199

May 29, 2001

Mr. Rich Mackin
P. O. Box 890
Allston, MA 02134

Dear Mr. Mackin:

Thank you for your very thoughtful and kind words. Your comments are being shared with all of the people who work on the product. I'm sure they'll be pleased to know they have been successful in their efforts to provide quality products for our valued consumers. I have enclosed a full value certificate in appreciation of your kind words.

Again, thank you for taking the time to contact us. If you have any additional questions or comments, please call me toll-free at 1-800-GILLETTE (445-5388). We always appreciate the opportunity to serve our customers.

Sincerely,

Maureen Mc Carthy

Maureen McCarthy
Consumer Service Representative

2638992A

Enclosure:
1 GILLETTE SERIES Shaving Gel or Shaving Cream

Dear Lucky Charms

Here is a haiku.

The Kids want his charms
Leprechan's cereal risked
Poor Lucky runs again

Enjoy,

Rich Mackin
POBox 890
Allston MA 02134

General Mills Consumer Services

P.O. Box 1113, Minneapolis, MN 55440

May 25, 2001

Mr. Rich Mackin
Box 890
Allston, MA 02134

Dear Mr. Mackin:

Thank you for contacting General Mills with your delightful comments. It was kind of you to share your thoughts and you have brightened our day. Many of our products have long attracted loyal fans. We are happy to see that you are among that group.

We appreciate your loyalty and hope you will continue to enjoy our products.

Sincerely,

Beverly Overvold

Beverly Overvold

LUCKY CHARM'S MARSHMALLOW PIECES

In 1964 L.C. Leprechaun began urging moms, "laddies" and "lassies" to buy Lucky Charms, a "most exciting cereal," and he has been echoing this message ever since.

This "charm-in" cereal contains oat pieces in various lucky shapes of bells, fish, arrowheads, cloverleaves and crossbars. What makes this cereal unique, however, is the addition of colorful marbits (marshmallow bits) that have delighted consumers for over 30 years.

Here is a little history about these "magically delicious" pieces:

The original product included four marbits:
Pink hearts
Yellow moons
Green clovers and Orange stars

In 1975 a fifth marbit was introduced – a blue diamond. The excitement was overwhelming!

In 1984 Lucky Charms added a new marbit to the fabulous five – the purple horseshoe

In 1986 a Swirled Whale made the scene, but was soon discontinued

In 1989 L.C. Leprechaun celebrated his 25th Anniversary in style by introducing the seventh marbit –A new red balloon!

And so it goes...

See if you remember these additions and changes:

1990: Holiday Lucky Charms – (red and green marbits)

1992: Rainbow (blue, yellow and pink)

1994: Pot of Gold (yellow and orange)

1995: Blue Moon (which replaced the yellow moon)

1996: Dark green clover in light green hat (which replaced the green clover)

1996: Olympic Marbits (red white and blue stars, a gold medallion with a yellow star in the center, a red-white and blue rainbow, and a yellow and green torch)

1997:Two colored twisted marshmallows (Moon, Balloon, Horseshoe, and Heart)
 Hot Air Balloon (pink)

And Most Recently:

1998: Shooting Star (orange star with a white fan effect behind it)

1998: Trip Around the World event with 8 new shapes (gold pyramid, blue Eiffel Tower, Orange Golden Gate Bridge, purple Liberty Bell, green and yellow torch, pink and white Leaning Tower of Pisa, red and white Big Ben clock and green and white Alps)

Look for new surprise shapes and colors! The sky's the limit!!

74

May 16, 2002

Dear Nike

Here is a haiku

For all his riches
Stolen from the work of slaves
Phil Knight's still ugly

Please respond,

Rich Mackin
POBox 890
Allston MA 02134

nike

July 1, 2002

Rich Mackin
PO Box 890
Allston, MA 02134

Dear Rich Mackin:

Please rest assured that Nike has nothing to hide. We have taken significant actions to improve the lives, opportunities, and working conditions of the people who make our products around the world. Our success as a company is based on fulfilling our responsibilities to the people who make our products; the communities where our products are made, sold and bought; the environment and natural resources that allow us to be successful; and the consumers who depend on our product excellence.

Nike unequivocally condemns child labor and our Code of Conduct specifically prohibits it. We have some of the toughest age standards in our industry. As specified in the Code, no workers under the age of 18 are allowed to work in factories that produce Nike footwear and no workers under the age of 16 are allowed to work in factories where other Nike products are made. We regularly monitor our partner factories to ensure they comply with these standards.

Nike understands the need to meet basic worker requirements by providing fair wages. The fact is Nike offers good wages, benefits and desirable jobs in countries where wages are low and jobs are scarce. We start by using country-mandated minimum wages as a foundation. In most cases however, entry- level workers earn more in cash and allowances than local governments require. In addition to wages, most workers also receive benefits such as housing, transportation, on-site health care and meals. Jobs in Nike contract facilities provide opportunities to build a lifestyle and life skills that are not typically available in other wage earning opportunities in the areas where our products are manufactured.

We have zero tolerance for abuse and harassment of workers. Our Code of Conduct specifically prohibits it. To achieve compliance with our Code and working standards, Nike labor practices managers educate and train factory partners. If factories are found in violation of the Code, we work with factory managers to encourage change and compliance. If violations continue however, Nike terminates its contract with these manufacturers. We have terminated ten contracts in the past two years but use this measure only as a last resort.

Nike also has some of the most comprehensive and independent labor-monitoring programs of any company in the world. We are involved in numerous monitoring systems –both internal and external. PricewaterhouseCoopers monitors every factory where Nike products are made every year to assess factory conditions. Additionally, internal SHAPE (Safety, Health, Attitude of management, People and Environment) audits measure factory improvements and compliance with Nike's standards. But it doesn't stop there. We are also part of the Global Alliance for Workers and Communities. This is a private, public and nonprofit collaboration that uses worker-driven evaluations to improve the workplace and living conditions of young adults involved with global manufacturing.

In terms of the Fair Labor Association (FLA), Nike will continue to support the organization because it enables activist, labor, consumer, university and manufacturing groups to work together to initiate change and establish protection for workers worldwide. This partnership has resulted in the creation of a single Code of Conduct that everyone can follow, and adjust, as needed. We strongly believe it is impossible to solve these complex issues without the input of those in a position to actually make change happen – the manufacturers and factory owners – sitting alongside consumer and human rights groups, trade unions and universities.

At Nike we know that globalization and human rights can and do – co-exist. That's why we work closely with non-profit organizations, governmental authorities, and other partners to ensure that our workers, and their communities, benefit from their relationship with Nike. Please visit our website at www.nikebiz.com for more details and the most current information about Nike's corporate responsibility programs.

Sincerely,

Nike USA Consumer Affairs

NIKE, Inc. One Bowerman Drive, Beaverton, OR 97005.6453 T.503.671.6453 F.503.671.6300 www.nike.com

Dear trident

You have these commercials where you say that millions of Americans or whatever all go to movies and eat all these snacks, but nobody brings a toothbrush...

But I usually have my courier bag on me, and I keep a toothbrush, paste and floss in it, so I can perform dental hygiene whenever I need to. That shows what you get for being so presumptuous. Have you heard the saying about when you ASS U ME???

Anyway, please have ads in the future say

"Nobody brings a toothbrush, except Rich Mackin."

Thank you,

Rich Mackin
POBox 890
Allston MA 02134

NO REPLY!

Dear Taco Bell,

I am writing to you about the general sadness I have over your new string of ads. Ad after ad are funny superficially- guys singing songs or calling each other funny names, but the overall, underlying message is downright depressing. Do you even notice this?

Think about it, a bunch of men in lame clothes- short sleeve button down shirts, khakis- obviously the dress of people who HAVE to wear ties for work, but far from being the power elite. These guys are what? Temps? Data entry guys? What do they do with their days that make them dress like that? And what do they do during lunch break, the one time from 9-5, now often 9-6 that the office drone has some freedom? Do they picnic? Do they hit a pub? Do they potluck, each bringing their cooking strongpoints in a showcase of Epicurean delights? NO! They eat cheap fast food! They leave their crowded florescent lit cubicles and sit at crowded florescent lit tables. Woe are they, the unhealthy uncultured office dwellers, prisoners of the cubicle, who are so myopic that they think Taco Bell makes them multicultural and that pop culture references makes them entertaining.

God have mercy on us all.

Rich Mackin
POBox 890
Allston MA 02134

NO REPLY!

Dear Listerine

Here is a haiku.

Listerine mouthwash
Gargle for breath freshener
Also gets you drunk

Enjoy,

Rich Mackin
POBox 890
Allston MA 02134

Pfizer Inc
201 Tabor Road
Morris Plains, NJ 07950
Tel 973 385 2000 Fax 973 385 3761

Warner-Lambert Consumer Group

May 29, 2001

Mr. Rich Mackin
PO Box 890
Allston, MA 02134

Dear Mr. Mackin:

This letter is in follow-up to your recent report regarding our product, Listerine®. You
informed us that you developed pain, discomfort, swelling and redness in your eyes
after use of this product. A report of an unpleasant experience with any of our products
concerns us.

We are interested in obtaining additional medical information regarding the symptom
you experienced after taking the product. Please complete our patient questionnaire
which has been enclosed with an addressed, postage paid envelope. If you have
already received, completed, and returned this questionnaire, please disregard this
request.

Thank you for taking the time to share this information with us. It is only through reports
such as yours that we may achieve the best monitoring of our products.

Sincerely,

Gabriela Gonzalez, RPh.
Product Safety Surveillance

Dear Rice Krispies

Here is a haiku.

Snap, Crackle, and Pop!
Puffed rice noise personified.
Sometimes Breakfast talks.

Enjoy,

Rich Mackin
POBox 890
Allston MA 02134

Kellogg's

May 31, 2001

Mr. Rich Mackin
PO Box 890
Allston, MA 02134

Dear Mr. Mackin:

It was thoughtful of you to take the time to let us know that you enjoy
KELLOGG'S® RICE KRISPIES®. We're always pleased to hear positive
comments from our consumers.

We're happy to have you as part of our consumer family. All of the
people at Kellogg devote a great deal of effort to developing wholesome,
appealing products, and it is good to know that you think we have been
successful.

Again, thank you for contacting us; we appreciate your interest in our
company and products.

Sincerely,

Laurie A. Giddens
Consumer Specialist
Consumer Affairs Department

Enclosure
lg2/mda

4021028A

79

Dear Starbucks

Here is a haiku.

I walk down the street
Starbucks, Starbucks, and Starbucks.
Full Saturation.

Enjoy,

Rich Mackin
POBox 890
Allston MA 02134

Starbucks Coffee Company
PO Box 34067
Seattle, WA 98124-1067
206/447-1575

June 1, 2001

Rich Mackin
PO Box 890
Allston, MA 02134

Dear Mr. Mackin:

Here's a haiku for you, too.

Thank you for the poem.
We all thought it was good fun.
Have some joe on us!

Have a great day!

Sincerely,

Geoff McCann
customer relations representative.

Dammit, how I hate that Starbucks was cool about this.
They sent me a few free coupons, too.

June 2, 2001

George W. Bush
The White House
1600 Pennsylvania Ave
Washington DC 20502

Dear Sir,

Thank you for responding to my letter about your tax cut. I am glad to see that you are concerned about saving American Taxpayers money.

Here is one suggestion- next time you write back to me, you can send the letter in a regular envelope with regular postage at 34¢ instead of sending the letter flat with a reinforcing piece of cardboard that uses extra materials and costs 76¢ to mail, like you did this time.

Using only the needed resources and minimal expenses are two simple ways that you can help conserve money and resources. If you need any further advice on such matters, do not hesitate to ask.

Thank you, have a nice day.

Sincerely

Rich Mackin
POBox 890
Allston MA 02134

May 22, 2001

Mr. Richard J. Mackin
Post Office Box 890
Allston, Massachusetts 02134-0006

Dear Mr. Mackin:

Thank you for contacting me about the tax burden on the American people.

Americans today are overtaxed. Federal taxes are the highest ever during peacetime. Americans pay more in taxes that they spend on food, clothing, and housing combined. Our citizens must work more than four months of the year just to pay their tax bills.

I believe it doesn't have to be this way. My budget that I submitted to Congress funds America's priorities, pays down historic levels of the national debt at a record pace, and provides fair and responsible tax relief for every American who pays taxes -- giving Americans a long-overdue refund. My plan will also spur economic growth and tear down the high tax barriers that prevent low-income Americans from joining the middle class.

My tax relief agenda replaces the current five-rate tax structure with four lower rates; doubles the child tax credit; reduces the marriage penalty; eliminates the death tax; expands the charitable tax deduction; and makes the research and development tax credit permanent. The big winners under my tax plan are low and middle-income families, millions of whom will be removed from the Federal tax rolls completely.

My tax relief agenda is fair and responsible and will spur economic growth, job creation, and brighter futures for all Americans – especially low-income Americans.

Thank you for taking the time to write on this important issue. I appreciate the chance to hear from you about your concerns.

Sincerely,

George W. Bush

Dear Post Pebbles (both kids)

Here is a haiku.

Some friend is Barney
Always stealing Fred's Pebbles
Why can't he just ask?

Enjoy,

Rich Mackin
POBox 890
Allston MA 02134

Consumer Resource & Information Center

June 4, 2001

Mr. Rich Mackin
Post Office Box 890
Boston, MA 02134

Dear Mr. Mackin,

Thanks for telling us how pleased you are with POST, PEBBLES, Cereal. When consumers like you take time to compliment our products, we know we're providing you with the highest quality products possible.

I am proud of our reputation for great food and great food ideas, and I want you to know we do everything in our power to maintain it. We are constantly looking for great food ideas with you in mind. We are committed to offering you the best products, not only now, but for many years to come.

Your satisfaction is what we want. After all, we want you to always purchase and enjoy our products. Together we can make something good!

Sincerely,

Kim McMiller
Consumer Resource Manager

7669548/10852545/RR/kgf

Enclosure
Story Of Post Cereals

KRAFT FOODS One Kraft Court Glenview, Illinois 60025 • (800) 323-0768
For Food & Family Ideas Visit Our Website at www.kraftanswers.com

84

Dear Heinz Ketchup

Here is a haiku.

Heinz varieties
Claim 57- of what?
Ketchup mystery.

Enjoy,

Rich Mackin
POBox 890
Allston MA 02134

Heinz North America

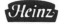

Consumer Affairs

Heinz U.S.A., Division of H. J. Heinz Comp
StarKist Seafood, Division of Star-Kist Foo
Heinz Pet Products, Division of Star-Kist F

Heinz Baby Food: 1 800 872 2229
All Other Heinz Brands: 1 800 577 2823
FAX: 1 412 237 5291

June 8, 2001

Mr. Rich Mackin
P.O. Box 890
Allston, MA 02134

Dear Mr. Mackin:

Thank you for writing and sending us your haiku. It was thoughtful of you to take the time to contact us.

We hope that you and your family will continue to enjoy our family of pure food products for many years to come. With this in mind, I've enclosed a complimentary coupon for your use.

Sincerely,

Patrick Dunegan
Consumer Affairs Representative

| 1333313A | PDU | **MANUFACTURER COUPON** | Expires 11/30/01 |

Free Bottle (up to 24 ounces) Heinz
Ketchup (including Heinz EZ Squirt)

Mr. Rich Mackin
P.O. Box 890
Allston, MA 02134

RETAIL VALUE $

705775

CONSUMER: Coupon good only in the USA on purchase of brand/size indicated. Void if copied, transferred, prohibited, or regulated. RETAILERS: Heinz USA will reimburse you for face value of this coupon plus 8¢ handling if redeemed in compliance with our redemption policy. Copy sent upon request. Cash value 1/100¢. Mail coupons to: Heinz USA, P.O. Box 870125, El Paso, TX 88587-0125.
LIMIT ONE COUPON PER PURCHASE. ©2001 H.J. Heinz Co.

THIS COUPON IS ONLY VALID IF PRESENTED WITH COLORED BACKGROUND.

5 13000 20001 6 (8100)0 70577

86

June 18, 2001

The Gap
900 Cherry Ave.
San Bruno, CA 94066

Dear Gap.

Today I read in Harper's Magazine, in the Harper's Index that you pay workers 11.6¢ for each shirt you retail for $12.99. I was thinking that I would save myself a trip to the store and just order one from you directly, and so if it costs about 3 bucks to ship a T shirt these days, I am enclosing a check for $3.116. You can choose the T shirt you send me.

How much does a hooded sweatshirt go for directly? I think it would be cool to have a sweatshop sweatshirt.

Thanks a bunch,

NO REPLY!

Rich Mackin
POBox 890
Allston MA 02134

Dear Alcatel

Here is a haiku.

Martin Luther King
Was not a corporate shill
Damn you, Alcatel!

Enjoy,

Rich Mackin
POBox 890
Allston MA 02134

▼

ALC▲TEL

June 21, 2001

Mr. Rich Mackin
P O Box 890
Allston, MA 02134

Dear Mr. Mackin:

We appreciate your feedback on our latest advertising campaign. There seems to be a slight disconnect between our intent and your perception of our current ad featuring Dr. Martin Luther King, Jr..

We do not believe that we have disrespected Martin Luther King's legacy. To the contrary, our intent is to honor his "I have a dream" speech – one of the most powerful moments in history.

Our overall campaign is based on outstanding examples of effective communication taken from history-- such as speeches, songs and historical events. The campaign is intended to raise the question: "What if these words, thoughts, ideas were never heard, or had never connected with people?" It leads to the statement that "for a passion to inspire a Nation, it has to reach the Nation."

To answer your question, Intellectual Properties Management, manager of the Estate of Dr. Martin Luther King Jr., granted us the rights to use Dr. King's likeness, and has approved of our advertisement which is now on air and in print.

When advertising around the world our intention obviously is to appeal to all viewers. While it is difficult to please everyone we want you to know that we greatly respect Dr. King's legacy and we recognize the important role he has played in the U.S. and around the world.

Sincerely,

Laurence Reale

McDonald's

Dear McDonald's

I am writing to you because of the beef in your fries. All these vegetarians are upset that you put beef in the fries and that when they go to McDonald's they can't eat the fries since they aren't vegetarian. So I bet you are getting lots of hate mail from them. When you write back, you should tell them that they are silly to care about what is vegetarian at McDonald's. Here are some points you can use...

- Anyone who is vegetarian out of concern for animals shouldn't go to McDonalds anyway- what that McDonalds is one of the biggest meat using and thus animal killing companies in the world, so it's silly to endorse them.
- Anyone who is vegetarian out of concern for the environment shouldn't go to McDonalds anyway-what with the wasteful packaging and the disposable and the rainforest cutting.
- Anyone who is vegetarian out of concern for politics shouldn't go to McDonalds anyway-what that your happy meal toys are made in sweatshops, and you deal predominantly with big corporate villains like Disney and Coke.
- Anyone who is vegetarian out of concern for health shouldn't go to McDonalds anyway- I mean, come on. If you want a salad, do you want a SALAD with vegetables or do you want iceberg in a cup?

So, feel free to put those veggies in place! If I was you, I would end all letters with "In your face!" but that's up to you.

If you need any more help, let me know.

Rich Mackin
P.O.Box 890
Allston, MA 02134

NO REPLY!

89

June 6, 2001

Angry Beaver Giggle Wiggle Stick
Nestle
Itasca Fl 60143

Dear Nestle.

So I was at a party in Emily's backyard on Memorial Day and she had the Angry Beaver Giggle Wiggle Stick. Now, you being the creator of this product can imagine what sort of sophomoric humor was brought up during the conversation regarding the naming of this item. As a whole, it was decided that this was a very poor choice of a name for a product for children.

However, it wasn't until I was sitting on the trampoline with Dave, Dave and Ziggy when one of them said "But if the beaver is ANGRY, why is he GIGGLING, that isn't keeping with the correct emotional response."

A hush fell over the crowd and I knew that we could not truly rest until we knew the answer.

Please respond.

NO REPLY!

Rich Mackin
POBox 890
Allston MA 02134

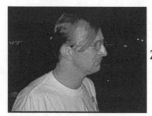

Ziggy

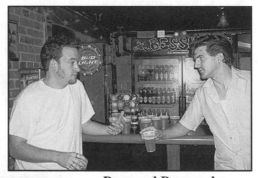

Dave and Dave and a
whole lot of beer.

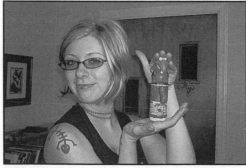

Emily with the Angry
Beaver Giggle Wiggle Stick

90

July 11, 2001

Frito- Lay
Plano, TX
75024-4099

Dear Frito Lay.

Bugsy sent me some " New! From Frito- Lay™ Dangerously Cheesy® Cheetos® Brand Whilz™ Crispy Puffs" and they just got me going on like I don't know what to do. I mean, my mind is racing! For one thing, the Dangerous level of cheesiness. What sort of danger am I in? I mean, are they Dangerous like Cigarettes are and you arc going to have Canadian snackers with Cheese damage on packages up there? What are the stages of Cheese Danger? Is it possible for me to sample a slightly risky cheese product to see if I am ready for Danger before I get in over my head?

Is the theory that these are Shuriken? (Aka ninja throwing stars?) If so, why? What is the deal of taking cheese coated puffed corn and making it shaped like any weapon, let alone one with so little use in the lives of most of your consumers? Wouldn't a gun or pipe bomb make more sense?

Why are parts of the name trademarked while others are registered?

I looked on the back of the package for a paragraph of insight along the lines of " I know what I like, and I like Frito's Corn Chips" or "Funions brand onion flavored rings are Fun!" but alas, no message.

Can you please provide some idea of what I am supposed to get out of these that has been improved over the standard Cheetos?

Thank you

Rich Mackin
POBox 890
Allston MA 02134

91

 Frito-Lay, Inc.

August 3, 2001

Mr Rich Mackin
P O Box 890
Boston, MA 02134

Dear Mr Mackin:

Thank you for contacting Frito-Lay.

We appreciate your inquiry about Cheetos Whirlz. The phase "Dangerously Cheesy" is simply a tongue and cheek way to communicate that this product is loaded with cheese. This is intended as a fun way to talk about this brand. We apologize if this was confusing or misleading in any way. The shape of Whirlz was designed as a fun shape for kids of all ages to enjoy. There is no hidden meaning in the name or the shape.

You are valued as our consumer, and we hope you will always look for Frito-Lay products whenever you are looking for great tasting snack foods.

Thanks again for your comments!

Sincerely,

Cathy Dial
Group Manager, Consumer Affairs

Enclosure: 2 Free Product Coupon

37262280

92

Fit Aug 15, 20001
Procter & Gamble Plaza,
Cincinnati, OH 45202.

Dear Fit,

What are you?

I mean, I know what you ARE, a produce wash, but what are you made of? Like why
would I need you, and not just water and/ or soap? How do I know what you put in
yourself? How have human beings been eating produce for centuries before you?

Now, rather than just asking rhetorical questions, I checked your web site on the so-called
internet, and I saw that you contain "all natural" ingredients including "oleic acid and
Glycerol" two things that I have no idea of what they are or what they do. "Ethyl alcohol"
which I know only can be used as a fuel, and so the statement that this comes from corn
does little to put me at ease. "Potassium hydrate" sounds fine, and the fact that it is from
'basic mineral' is nice, but your accompanying visual of beach pebbles concerns me.
Baking soda, while common, scares me. What is baking soda? Where does it come from?
I am sure that my grandparents probably could make it from scratch in their day, but
today, it is a mystery item that in my life of takeout is merely the air freshener of my
freezer. Citric acid and grapefruit oil seem odd in that I might want to use the product for
citrus fruits like Grapefruit.

Can you go into some more detail? Please?

Rich Mackin
P.O.Box 890
Allston MA 02134

93

Procter&Gamble

Public Affairs Division
P.O. Box 599, Cincinnati, Ohio 45201-0599
www.pg.com

Our ref: 630991
October 27, 2000

MR RICH MACKIN
P O BOX 890
ALLSTON MA 02134

Dear Mr. Mackin:

Thanks for contacting P&G about Fit and giving us an opportunity to answer your questions.

There are advantages to using Fit in place of plain water and/or soap. There are some substances (like wax) that are water-insoluble, and therefore can't be adequately removed using water along. Some chemicals used in growing produce can also be water-insoluble so that they won't be removed by rain. Besides, using soap or dishwashing detergent on produce isn't recommended because those products haven't been formulated for use on produce, and they're harder to rinse off.

All of Fit's ingredients come from 100% all natural sources. Ingredient information other than what we have on our web site is considered proprietary but all of Fit's ingredients have been approved by the FDA for food use.. I can tell you, that oleic acid is a key ingredient for removing unwanted residues from surface of produce. Both ethyl alcohol and glycerol control viscosity over a broad temperature range, but the latter also provides lubricity for washing produce. Potassium hydrate and baking soda help make the oleic acid water soluble. Potassium hydrate increases the product pH to enhance its overall cleaning performance, while baking soda provides alkalinity to enhance cleaning. Citric acid enhances cleaning, (especially in hard water), and grapefruit oil gives Fit its fresh, clean, natural scent.

I hope this information is helpful. If you have any further questions, you may want to check out our FAQ's at: http://www.tryfit.com/faq.htm. Thanks again for contacting us.

Sincerely,

Stephanie Doherty

July 10, 2001

Mayor's Office
300 E. Jackson St.
Tampa, FL 33602

Dear Tampa, Florida,

I am writing to you about how you, you meaning not the entire city, but some officials or representatives, have installed security cameras all over the public streets to monitor just about everyone as they do just about everything.

Ok, stop me if this is already the plan, and you are just on phase one, but I was thinking about how security cameras everywhere = big brother and that Florida = theme parks and so so the logical conclusion of this would be for Tampa to open "Orwellland"- like Disneyland, but totalitarian. You could have like a house of horrors with torturers interrogating the customers, midway games involving Newspeak and doubletalk, you could call the security force the Ministry of fun, it would be great!

Please let me know if you would like me to help design some rides,

Sincerely,

Rich Mackin
POBox 890
Allston MA 02134

8/29/01

Governor Don Siegelman
State Capitol
Room N-104
600 Dexter Avenue
Montgomery, AL 36130

Dear Sir,

I am writing to you in reaction to your comment,

"If God wanted you to wear earrings, he would have made you a girl."

Would you please send me the Bible Passage that is from?

Furthermore, could you send me some documentation that God wants girls to have their ears pierced?

Thank you.

Rev. Richard J, Mackin
POBox 890
Allston MA 02134

P.S. I like the car ads on your web site (http://www.governor.state.al.us/index2.htm)
P.P.S. I think Alabama is the best smelling state! It smells like Fourth of July
(fresh mown grass, BBQ, and gunpowder!)

DON SIEGELMAN STATE OF ALABAMA / OFFICE OF THE GOVERNOR **ALABAMA**

Quick Links: ⬍

WELCOME

NEWS

PRESS
RELEASES

IMAGE
GALLERY

CONTACT
US

FIRST LADY

HOME

WELCOMES TOYOTA

Toyota & Alabama
$220 Million Plant Announced

Mercedes
Expansion
in Alabama
2000
new jobs

NEWS click on links for details

Siegelman announces 13 new early learning sites

HONDA & Alabama
Breaking New Ground

Honda & The Governor
at the NYSE

real player

Alabama State of the State Address
View video of the Governor's speech online. Requires
Real Player. Click on link above for instructions.

Amendment One - Siegelman Credits Diverse Base of
Support
Success of Amendment will Result in Bridge Repairs,
Revitalization of State Port and Improvement of
Agriculture and Forensics Labs

1999-2000 Report Card on Alabama's Public Schools
"We are holding schools accountable to the public and
to the families they serve."

To translate this site use Internet
Explorer 5.0+ and choose a
language option:

French	Portuguese
German	Japanese
Italian	Korean
Spanish	Chinese

See disclaimer & usage notes at
bottom of page.

AlaWeb | First Lady Home | Help design by ISI

Alabama
Virtual Library Register to VOTE from home CLICK IT 'OR TICKET'

Translation courtesy of Babel Fish & SYSTRAN as a free service and is not endorsed by State of Alabama or the Office of the
Governor. Translation accuracy is not guaranteed nor implied. Please read the Translation FAQs to be aware of the translation
limitations and other usage information.

This is an actual printout of Governor
Siegelman's web site. Several months later,
he sent me a card.

December 2001

We are all so blessed to
live in America & Lori &
I pray for our brave
men & women, who proud-
ly go to war, so we can
continue to live in a free
Country.
we know just how lucky

we all are, to be together,
as a family, in Alabama,
in America!
May God bless us all,
with a year of peace &
happiness. Dana, Joseph
Lori & Don

May 16, 2002

Dear Dr Pepper

Here is a haiku

Come from what med school?
Not black nor jalapeno.
Your name makes no sense.

Please respond,

Rich Mackin
POBox 890
Allston MA 02134

Dr Pepper/Seven Up, Inc.
Consumer Relations
P.O. Box 869077, Plano, Texas 75086-9077
5301 Legacy Drive, Plano, Texas 75024
800-696-5891

June 27, 2002

Mr. Rich Mackin
P O Box 890
Allston, MA 02134

Dear Mr. Mackin:

Thank you for contacting Dr Pepper/Seven Up, Inc. Your comments and inquiries are appreciated because they provide valuable feedback about our brands.

Dr Pepper/Seven Up, Inc. is proud to be the largest non-cola and third largest soft drink manufacturer in the United States. We produce solely the flavoring concentrates from which various brands of soft drinks are made. These concentrates are then sold to independent franchised licensed bottlers who produce and distribute the finished soft drink product to retailers for sale to consumers.

We appreciate your comments and hope you will continue to select and enjoy our soft drink brands. Also, please visit our Web sites at www.dpsu.com, www.drpepper.com and www.7up.com.

Sincerely,

Chris Evans

Chris Evans
Consumer Relations Coordinator

Enclosure: Dr Pepper History

May 16, 2002

Dear Spam

Here is a limerick

Hormel's infamous product called Spam
Much more than the referenced spiced ham
Who first thought of this plan?
Processed meat in a can
As American as Uncle Sam.

Please respond,

Rich Mackin
POBox 890
Allston MA 02134

Hormel Foods Corporation
1 Hormel Place
Austin MN 55912-3680
Phone 1 800 523 4635

June 17, 2002

Mr Rich Mackin
PO Box 890
Allston, MA 02134-0006

Dear Mr Mackin,

Thank you for contacting us with your limerick and your inquiry. We appreciate your interest in the origin of the SPAM name.

SPAM brand is a distinctive and famous trademark for canned meat, recipes, wearing apparel and novelty items. Kenneth Daigneau, brother of a Hormel Foods Vice-President suggested the name at a New Year's Eve party in 1936. The trademark was originally derived by contracting "spiced ham". Immediately after the term was coined, it became a distinctive trademark of Hormel Foods Corporation. This trademark is not considered a contraction.

For additional information about SPAM brand products, please visit our website at www.spam.com

The enclosed information and recipes are for your use.

Sincerely,

Gina

Gina Lundberg
Consumer Response Specialist
Ref # 805321

May 16, 2002

Dear McDonald's

Here is a limerick

McDonalds hamburgers are fun.
Low grade meat on a lower grade bun.
The destruction of health
Goes to CEO wealth
With packaging waste by the ton!

Please respond,

Rich Mackin
POBox 890
Allston MA 02134

McDonald's Corporation
McDonald's Plaza
Oak Brook, Illinois 60523-1900
Direct Dial Number

(630) 623-6198

June 21, 2002

Mr. Rich Mackin
PO Box 890
Allston, MA 02134-0006

Dear Mr. Mackin:

Thank you for contacting McDonald's with your comments and concerns.

McDonald's hamburger patties are made from "100-percent pure beef-made of whole muscle and hand-trimmed cuts—with no additives, extenders or fillers", hamburgers. As for the buns, McDonald's is committed to serving high quality food products. Not only do we meet government standards, but in many cases, we exceed them.

It's important to know that meal choices at McDonald's can fit within a healthy lifestyle, and we have voluntarily provided nutritional information for more than twenty-five years to help our customers make informed choices when eating at our restaurants. Ultimately, it's important to remember that it is up to each individual customer to make wise decisions regarding their health.

Finally, as the founder of McDonald's once said, "Conserve and serve". McDonald's effectively manages solid waste by reducing, reusing, and recycling. We are committed to conserving and protecting natural resources. McDonald's also encourages environmental values and practices.

Once again, Mr. Mackin, we appreciate your comments because customer feedback is what strengthens the quality of our service.

Sincerely,

Miriam Cardenas

Miriam Cardenas
Customer Satisfaction Department

May 16, 2002

Dear Jello

Here is a limerick

State of Utah's official state treat
A consistency that's really neat
It comes in green and pink
You know, you'd never think
That it comes from an animal's feet!

Please respond,

Rich Mackin
POBox 890
Allston MA 02134

Consumer Resource & Information Center

August 10, 2002

Mr. Rich Mackin
PO Box 890
Allston, MA 02134-0006

Dear Mr. Mackin,

Thanks for sharing your interest in our promotion and advertising campaigns for JELL-O, Brand Gelatin Dessert. I'm glad to have the chance to explain how this works.

As we develop our advertising, we work exclusively with advertising agencies hired to create and produce our advertising campaigns. We have specific policies that prevent us from considering any unsolicited suggestions for our ads.

Over the years, we have received thousands of letters from our good friends like you who submit poems, songs and slogans inspired by our products. Although we can not use this material, we think it's kind of neat to receive it. I hope you understand our position is not a reflection of your creativity.

While we can't use your idea, we certainly appreciate you thinking of us and hope you'll continue to use and enjoy our products!

Sincerely,

Kim McMiller
Consumer Resource Manager
Ref: 3561595N
enclosure

KRAFT FOODS One Kraft Court Glenview, Illinois 60025 • (800) 323-0768
For Food & Family Ideas Visit Our Website at www.kraftanswers.com

May 16, 2002

Dear Coca Cola

Here is a haiku for you

Oh liquid candy
Rotting teeth and minds of youth
And can dissolve nails

Please respond,

Rich Mackin
POBox 890
Allston MA 02134

The Coca-Cola Company

COCA-COLA PLAZA
ATLANTA, GEORGIA

ADDRESS REPLY TO
P.O. BOX 1734
ATLANTA, GA 30301
404 676-2121

June 25, 2002

Mr. Rich Mackin
P.O. Box 890
Allston, MA 02134

Dear Mr. Mackin:

Thank you for contacting The Coca-Cola Company. We certainly appreciate your interest in Coca-Cola classic and are happy to address your concerns.

Please be assured, none of our beverages contain harmful substances. All Coca-Cola brand soft drinks are wholesome beverages manufactured in compliance with the Federal Food Laws, the laws of all the states, and the laws of nearly 200 countries throughout the world where Coca-Cola products are marketed.

Unfortunately, there is a lot of misinformation on the Internet concerning the safety of foods and beverages. It is disappointing that the Internet's remarkable capacity to transmit information is being so abused.

You may be interested to know there is a small amount of edible acid present in many foods, including fruit juices, buttermilk, and soft drinks. Acids, such as phosphoric and citric acid, add a pleasant tartness to a beverage. Any acidic food or beverage has the potential to have the effects you've described. However, these foods are not acidic enough to harm your body tissues, in fact, regarding the effect soft drinks have on the stomach, you'll be interested to know that the acids secreted in your stomach to digest foods are stronger than those found in most foods. The acids in most foods are neutralized to a large degree by the saliva in the mouth long before they reach the stomach.

The consumption of soft drinks, including colas, does not cause weak bones. In fact, the amount of phosphorus found in soft drinks is similar to the level found in orange juice. Insufficient calcium intake, hormonal imbalances, and a lack of physical activity are the primary causes of weak bones.

Coca-Cola does not cause kidney stones. In fact, the opposite is true.
An inadequate intake of fluids is a major contributing factor to the
formation of kidney stones. Soft drinks provide a pleasant and
refreshing way to consume part of a person's daily fluid requirement,
thereby encouraging adequate fluid intake.

Eating cold foods does not lower body temperature. Everything we eat
and drink, hot or cold, turns the same temperature in the body. Body
temperature is a constant 37°C (98.6°F). Eating hot food does not raise
body temperature. Just the same, eating cold foods does not lower body
temperature.

Most people eat many kinds of foods--some hot and some cold. The
temperature of the food does not effect how the body uses or metabolizes
the food. The body breaks down foods into the basic parts: sugars,
starches, fats, and proteins. This always happens the same way
regardless of whether the food is hot or cold.

Carbon dioxide, when added to water for carbonation, is not harmful upon
ingestion. Like other food ingredients, carbon dioxide has been
reviewed by regulatory authorities worldwide and its safety has been
confirmed. Carbonation has no documented effects on the
gastrointestinal tract or on general health. Carbon dioxide occurs
naturally in the atmosphere as a colorless, odorless gas. It is what
plants take in and what we breathe out. Ever since the first
effervescent soft drinks were made, the same ingredient has been used to
make them bubble. Like other food ingredients, carbon dioxide has been
reviewed by regulatory authorities worldwide and its safety has been
confirmed. The story about the student at Delhi University is not true.

The rumor you read also stated soft drinks were harmful to teeth and the
stomach. Comments such as "a tooth placed in a glass of a soft drink
will disappear" are misleading. This in no way creates a real life
situation. The teeth in your mouth are alive, not dead. They're
exposed to Coke for only a short amount of time rather than sitting for
days in a glass of Coke.

Although many soft drinks are acidic in nature, under normal consumption
conditions, they are no more acidic than many fruit juices, including
orange juice. Because your teeth are constantly bathed by saliva, which
helps buffer the effects of acids from beverages and foods, the effect
on tooth enamel is greatly reduced. Finally, saliva contains minerals,
such as calcium, phosphorus and fluoride, which replace any mineral
loss from the tooth enamel. This protection is lost when an extracted
tooth is placed in a glass of liquid.

Our soft drinks are marketed as beverages to be consumed for pleasure
and enjoyment. Hence, we do not make any claims relating to other uses,
and would therefore recommend using products which were designed for the
uses described. We believe there has always been, and always will be,
plenty of room in a balanced diet for consumption of pleasant soft
drinks.

The other claims in the message may be true to a lesser extent because
there is a small amount of edible acid present in many foods, including
fruit juices, buttermilk, and soft drinks, such as Coca-Cola. These
foods are not acidic enough to harm your body tissues--in fact, your own
natural stomach acid is stronger. It is possible that the edible acid
in any of these products could have the effects described in the email
you mention, even though it's still quite safe to drink these products.
However, we don't make any claims relating to other uses. Instead, we
recommend using products which were designed for cleaning or rust
removal.

Please accept the enclosed as tokens of our appreciation for your
interest in our company and Coca-Cola classic. Should you ever have any
further comments or questions, please feel free to contact us again.

Sincerely,

Stacey R. Burch

Stacey R. Burch
Consumer Affairs Specialist

Encl: Top Ten brochure
 Ingredient Packet
 2002 Calendar

May 16, 2002

Pepperidge Farm, Inc.
595 Westport Ave.
Norwalk, CT 06856

Dear Pepperidge Farms

Here is a limerick

Many people these crackers do please
To eat just one is a tease
But what nobody knows
Is why you juxtapose
Shape of goldfish and flavor of cheese.

Please respond,

Rich Mackin
POBox 890
Allston MA 02134

June 20, 2002

Mr. Rich Mackin
P. O. Box 890
Allston, MA 02134

Dear Mr. Mackin:

Thank you for sending us the limerick.

Right from its start in 1937, Pepperidge Farm has always tried to produce both delicious and nutritious products. Since we put a great deal of effort into our products, we are pleased to learn that this effort is appreciated.

While we cannot tell you why we chose the shape of goldfish, or the taste, we can tell you that we market products that received the best response during testing.

Thanks again for your interest. We hope you will continue to enjoy our products.

Sincerely,

J.M. Teja
Consumer Representative

1483905A

June 10, 2002

Anusol
C/o Warner Lambert Company
Morris Plains, NJ 07950

Dear Anusol

I have a question, are you pronounced "Anu- Sol", so that the n is like in onion, or "Anus- ol". Like "Anus- All" would be pronounced. Or is there another pronunciation I am overlooking?

Sincerely

Rich Mackin
POBox 890
Allston MA 02134

Consumer Affairs
Pfizer Inc
182 Tabor Road
Morris Plains, NJ 07950
Tel 800 223 0182 www.prodhelp.com

 Pfizer Inc Consumer Group

June 20, 2002

Chip Horner
Senior Director, Consumer Affairs

MS RICH MACKIN
PO BOX 890
ALLSTON MA 02134

Dear Ms. Mackin,
Thank you for contacting Pfizer Consumer Healthcare regarding Anusol.

Pfizer prides itself on producing the highest quality products that meet the needs of our consumers. We are fortunate to receive thousands of comments from our consumers each year.

Thank you again, Ms. Mackin, for your interest in Anusol. If we can be of further assistance to you, please do not hesitate to contact us at 1-800-223-0182, Monday through Friday, 8:30 a.m. to 5:00 p.m. Eastern Standard Time (EST) or visit us on the Internet at www.prodhelp.com.

Sincerely,

Sandra Siravo
Communicator

110

June 28, 2002

Anusol
C/o Warner Lambert Company and/or Pfizer
182 Talbot Rd.
Morris Plains, NJ 07950

Dear Anusol

Today when I checked my mail I got a letter from you addressed to Ms. Mackin. I am not sure if you are trying to imply that I am gender bending or merely or that you are emulating the diabolical work of Frugal Fanny, but in any case, it wasn't appreciated.

I would thank you for your letter, but it didn't actually address what I wrote about- the pronunciation of Anusol. I do thank you for the coupon, but I fear I will mispronounce what I have a coupon for when I proudly declare it to the cashier.

Finally, I am a bit confused why Pfizer is writing to me when I originally wrote to Warner Lambert.

Sincerely

Mr. as in Male Man Rich Mackin
POBox 890
Allston MA 02134

Consumer Affairs
Pfizer Inc
182 Tabor Road
Morris Plains, NJ 07950
Tel 800 223 0182 www.prodhelp.com

 Pfizer Inc Consumer Group

July 08, 2002

Chip Horner
Senior Director, Consumer Affairs

MR RICH MACKIN
PO BOX 890
ALLSTON MA 02134

Dear Mr. Mackin,

We received your recent correspondence, and we are interested in speaking with you directly.

We have tried to reach you by telephone but have been unsuccessful. We would value and appreciate the opportunity to speak with you personally and ask that you call us at your earliest convenience. We are available to speak with you Monday through
Friday between the hours of 8:30 a.m. and 5:00 p.m. (EST) by dialing 1-800-223-0182. When calling, please provide the reference number listed above to the telephone consultant.

Thank you for taking the time to contact Pfizer Consumer Healthcare. We look forward to assisting you.

Sincerely,

Sandra Siravo
Communicator

 Oh man, does having these companies call me creep me out. Why the hell can't they just write the answer? I don't want to call them. It feels like a trap.

112

June 28, 2002

Gap
5900 North Meadows Drive
Grove City, OH 43123

Dear Gap

Thank you for your letter that said
"How (you) operate reflects (y)our values and business ethics." You should have added
the phrase "or lack thereof."

But seriously, saying that your actions reflect your ethics doesn't mean much when your
ethics are pro-sweatshop and anti-forest. I mean, the Nazi's actions reflected their ethics.
The men who crashed planes into the World Trade Center were showing their ethics.
When you guys clear cut-forests and exploit human beings, yes, you do operate in
reflection of the miserable, selfish and self-serving ethos that somehow may allow you to
sleep at night.

And I am reflecting my values, beliefs and business ethics when I tell you to take your
bland homogenized-culture, sweatshop-stained environment, worker and independent
thought killing operation and go back to whatever hell the Fisher family comes from.

Please respond,

Rich Mackin
POBox 890
Allston MA 02134

P.S. At some point, a real human being will read, or at least skim this. Is being the lackey
of sweatshop lords reflecting YOUR values, beliefs, and business ethics?

Gap Inc.

Gap
Banana Republic
Old Navy

5900 North Meadows Drive
Grove City, OH 43123

www.gapinc.com

July 5, 2002

Mr. Rich Mackin
PO Box 890
Allston, MA 02134

Dear Mr. Mackin:

Thank you for your letter and the opportunity to provide you with the following information about our sourcing practices.

How we operate reflects our values, beliefs and business ethics. Since many people are interested in learning more about our sourcing practices and global compliance efforts, we have developed a section on our corporate Web site that gives a broad range of information surrounding this topic. Please visit the Social Responsibility section on gapinc.com, and click on Ethical Sourcing for more information.

Sincerely,

Gap Inc.
Global Compliance

Aug 1, 2002

Dear Gap

Thank you for your form letter in response to my making fun of your form letter.

The very fact you sent me ANOTHER form letter indicates the fact that you really are a faceless evil corporate empire. Despite the fact that you had a chance to actually address what I said in the letter, you are already sending me, you choose merely to tell me to check out your web site, which further shows how myopic and presumptuous you are.

I do have a computer, I am using it now, but many people don't have computers. Some people who don't have them include pretty much everyone who works in the factories that make your clothes, because since you barely pay them enough to eat, I doubt you are also handing them free electronics.

I look forward to receiving another copy of your form letter,

Rich Mackin
POBox 890
Allston, MA 02134

NO REPLY!

114

June 25, 2002

Al Gore
C/o Democratic Senatorial Campaign Committee.
Pobox 1849
Merrifield, VA 22116-9779

You, a wealthy man, wrote me, a less wealthy man, asking me for money to help elect Democratic Senators. As you already know, most Senators also already have more money than me. Surely they have wayyyy more money than most people.

For one thing, I live in Massachusetts. This means that Kennedy is a Senator. You could run Christ on the second-coming on the Republican ticket against him, and he will still win. You could also run a dead cat for any Democratic office, and it would win.

I don't know if you were trying to be funny in your letter, but you did get a few good ones in there. For one thing, you called Bush the President. Wow, how whipped can you get? In the election I was watching, it seemed that you won on all accounts. But you seceded. This makes me dub you a wuss. You of all people know Bush doesn't really have any claim to the presidency, and you're just encouraging him.

I also liked the line about Democratic Senators being committed to helping families caught in the current economic downturn. I mean, I know that you aren't trying to screw people the way that Republicans do, but you really need to admit that being the lesser of two evils still makes you evil.

Of course, it's also funny when wealthy sons of wealthy men ask real, working people for money.

Thanks for the laughs and the postage paid envelope to share my thoughts.

Rich Mackin
POBox 890
Allston MA 02134

NO REPLY!

 Um, um, okay, well Mass just elected a Republican Governor, so I will shut up. Doesn't make me want to give Al Gore any more money, though.

Aug 6, 2002

VF Jeanswear
Limited Partnership
Corporate HQ
400 North Elm St.
Greensboro, NC 27401

Dear Wrangler Jeans

I don't watch TV that much these days, and I was thinking that it was doing me good. But then I got sick and needed to have something occupy my mind without challenging it, so good old VH1 came to the rescue. While watching some sort of documentary, I saw your ad for your jeans that used the song "Fortunate One" (Fortunate Son?) in the background. Now granted, the part you use is just phrases like "red, white and blue" and unless the viewer knows the song, they wouldn't know that the song is about how the wealthy people of this country use their privilege to stay out of war while sending the poor to die on our imperial conquests.

Now, it is possible that you will take the same argument that Pringles did, when they used the anti-cop song "jump around" in their ad, as if referencing part of a piece of art in a new context destroys the whole context. But that would be silly, there are many patriotic songs that aren't attacks on America's overclass that you could have used. Certainly you don't think that few Americans would miss the connection, and surely, connections are what advertising and branding is all about.

Is it possible that Wrangler is being truly patriotic? By loving the principles of this country- freedom, democracy, equality, and is making a bold statement about our unelected "leader", George Dubya, born with a silver cruise missile in his mouth? That is what I think…and hope.

Good for you Wrangler, you are one tough customer.

Please respond,

Rich Mackin
POBox 890
Allston MA 02134

NO REPLY!

Aug 7, 2002

Dear Diet Pepsi.

I am unsure of the point of your ad. The new ad that uses footage from Easy Rider and has some fat bald middle management stereotype dreaming that he was "born to be wild" by riding his motorcycle with Peter Fonda, when in reality, he is drinking Diet Pepsi in a bus.

First of all, the whole point of the rebellious sixties motorcycle road trip lifestyle is to reject the stupid points of materialist, capitalist society. The first thing to go would be diet soda from multinational conglomerates. Isn't the fact that the pro-Pepsi fat guy dreaming of leaving his Pepsi-drinking ways behind actually countering the point of you guys making the ad?

Also, what you don't seem to recall is that while Easy Rider has these guys having fun until some redneck shouting "get a haircut!" shoots and kills them. Is the idea is that the fat guy hates his middle management, Diet Pepsi drinking life so much he would rather dream of short freedom and sudden death? If this is the case, why doesn't he do something more proactive than just listen to headphones and drink chemicals?

Or, is the idea that since he is balding and has barbered hair, that in this retelling of the film, the rednecks would spare him, as he does not need the fatality inducing haircut?

Is the point of the ad that if one of that the guys in Easy Rider were a fat balding hypocrite, they would have lived long enough to sell out; that a short life of freedom is better than getting old and fat on the bus to middle management; or that Diet Pepsi is the official drink for men who choose to only be free in their dreams?

Please respond,

Rich Mackin
POBox 890
Allston, MA 02134

NO REPLY!

117

August 16, 2002

Philip Morris
120 Park Drive
NYC NY 10017

Dear Philip Morris

I was thinking about your (new?) slogan.

"Working to make a difference. The people of Philip Morris."

Wouldn't a more logical use of language be
"The people of Philip Morris are working to make a difference?"
It would be like if Christ wrote the Sermon on the Mount like
"Shall be inheriting the earth. The meek."

It's just kind of awkward, you know? What's up with that? I mean, how much thought
did you put into this?

And the thing is, saying that you are making a difference doesn't really mean anything.
You aren't saying "working for the common good" or "working to make the world a
better place" you are just making a difference. Hitler made a difference. A major
earthquake makes a difference. When the planes crashed into the twin towers, they made
the NYC skyline different. Heck, to get less melodramatic about it, you know when
someone gets a new haircut, and it's really bad, but you don't want to offend them, what
do you say "Well, it sure is DIFFERENT". Or like in the musical A CHORUS LINE
"Different is nice, but it sure isn't pretty, and pretty is what it's about."

Can you please clarify?

Rich Mackin
POBox 890
Allston MA 02134

NO REPLY!

118

Dear Necco

Here is an exerpt from the MULTINATIONAL MONITOR:

Debbie Kruger created the Lewis & Clark bar in 1997 to commemorate the
upcoming two-hundredth anniversary of the expedition led by Meriwether
Lewis and William Clark up the Missouri River from St. Louis in 1804
(She) has manufactured roughly 30,000 Lewis & Clark bars. She has
sold about 20,000 of them.

In September 1999, the Krugers received a letter from a lawyer in Boston.
The lawyer said he represented the New England Confectionery Company
(Necco) -- the makers of Necco wafers and those little heart candies that
say things like "Marry Me," "Be Mine," and "Kiss Me."

Necco, which is owned by UIS, a larger conglomerate, recently bought the
company that makes the Clark Bar, and the Boston lawyer claimed that the
Lewis & Clark Bar infringes on Necco's rights to the Clark Bar name

THAT IS SO LAME!

Please go back and time and stop Lewis and Clark from becoming explorers. That way,
nobody will ever want to honor them. While you are at it, sue the makers of Superman-
his alter ego is CLARK Kent, which infringes on your name. Also, the father in the
VACATION movies is named CLARK- so sue National Lampoon. I am also enclosing
pages from the Boston Area white pages containing several hundred Clarks- that's over
500 lawsuits that you can have without even making a long distance phone call!

This letter is not in spite of being denied a factory tour.

Please respond,

Rich Mackin
POBox 890
Allston MA 02134

NO REPLY!

119

June 27

Colgate Palmolive Company
New York, NY 10022

Dear Colgate.

Dave emailed me the other day about his toothpaste. It was his toothpaste in that he owned the tube, but it was also your toothpaste- Colgate Baking Soda & Peroxide Whitening with Tartar Control Fluoride Toothpaste. According to Dave, however, it was more like Colgate Slimy Baking Soda & Peroxide Slimy Whitening with Slime, Tartar Control, and Slime Fluoride Toothslime. Needless to say, he was not pleased with the product, I think it's safe to say that his complaint was oriented towards the sliminess. He said that it made his spit into long strings of slime that would hang like tendrils from his mouth to the toothbrush. He offered to brush his teeth to show me, but somehow, the idea wasn't all that appealing.

He showed me the list of ingredients as we pondered the slime. While we didn't see anything that clearly said "slime" or even anything that directly implied slime, we wondered what things like Aluminum Oxide, Pentasodium Triphosphate, and Tetrasodium Pyrophosphate were, and what business they had in toothpaste. Dave maintains it must be one of these that makes the slime.

Here's the kicker. While researching this all, Dave's girlfriend came across the article "Paste Test" by Seth Stevenson on the web site http://slate.msn.com/?id=3604 which maintains that whitening toothpaste is a rip off because it doesn't actually make the teeth whiter- it merely removes surface stains, which ANY toothpaste does.

Please explain.

Rich Mackin
POBox 890
Allston MA 02134

NO REPLY!

120

Aug 16, 2002

POBox 1734
Atlanta, Georgia 30301

Dear Coca Cola

A friend of mine lives on the other side of the country and was asking me if I saw the stupid new Dasani ads that feature women about to pour your bottled water into their faces, but instead of opening their mouths to receive the water, they instead have big smiles, which is nice, but means that the water will simply splash off the teeth and not be refreshing.

Anyway, we were "instant messaging" on the internet and looked at your web sites to see if I could see these ads, and while we never found them, we did find that you make the product known as "Bimbo."

I find it strange that up until now, you have kept this product a secret from me. What's the deal. Suppose instead of asking for a Coke at the next diner, I ask for a Bimbo? What is going to happen? I know that I want to at least try a Bimbo. And while I cannot say I will like an regularly use Bimbos, I can say I feel that as long as I don't have a Bimbo in my life, I feel like something is missing.

Please respond Send me a coupon for Bimbo.

Rich Mackin
POBox 890
Allston, MA 02134

The Coca-Cola Company

COCA-COLA PLAZA
ATLANTA, GEORGIA

ADDRESS REPLY TO
P. O. DRAWER 1734
ATLANTA, GA 30301
1-800-438-2653

August 26, 2002

Mr. Rich Mackin
P.O. Box 890
Allston, MA 02134

Dear Mr. Mackin:

Thank you for your letter inquiring about the availability of Bimbo.

The Coca-Cola Company makes over 300 brands worldwide, and some of our brands are only available in specific countries or in certain regions of the United States. Local bottling companies choose which brands to package and sell in their territories based on consumer demand and other market factors. Unfortunately, we do not have plans for this brand in the U.S. Since bottlers are not able to ship products out of their territories, we regret that you won't be able to purchase Bimbo in the U.S.

I have enclosed a few items as tokens of our appreciation for your loyalty to our brands. Please feel free to contact us if you have any additional questions. Best wishes!

Sincerely,

Jeffrey C. Distler
Consumer Affairs Specialist

Encl: 2001 Annual Report
 Brand Card
 Coupon

122

Aug 23, 2002

Dear Gap,

I find it ironic that your new ads for Gap stretch pants use a boney woman with no real curves to speak of. (Or , as a friend said, "She ain't got no ass") what's the point of wearing something that stretches when you hang them off your coat-hanger like body?

Please Respond,

Rich Mackin
Pobox 890
Allston MA 02134

P.S. I don't know about you and your personal opinions, but most people I know find curves attractive on women. That's why we find women attractive, not skeletons.

Gap Inc.
Gap
Banana Republic
Old Navy

Two Folsom Street
San Francisco, CA 94105
650 952 4400 tel
www.gapinc.com

October 15, 2002

Mr. Rich Mackin
P.O. Box 890
Allston, MA 02134

Dear Mr. Mackin,

Thank you for your letter regarding our recent ad for stretch pants. We're sorry to hear you don't care for it.

We realize there are as many different tastes and preferences as there are individuals. Consequently, we try to create a variety of marketing pieces in an effort to reach everyone who shops with us at one time or another. We're always glad to pass on feedback like yours, and we'll do our best to create materials that you find appealing in the future.

Sincerely,

Amy Spencer
Corporate Communications

Sept 4, 2002

Dear I Can't Believe it's Not Butter,

You're right, I CAN'T believe it's not butter, here is a photo documenting my disbelief.

Do you have any more like this of you guys in the office? Although, I guess after working there for a few years, you must eventually start to believe that it's not butter I guess.

Take care,

Rich Mackin
POBox 890
Allston MA 02134

NO REPLY!

customerservice@pcdj.com
sales@pcdj.com
webmaster@pcdj.com

Dear PCDJ staff,

I was linked to your website, http://www.pcdj.com/ by a friend who, at first, I thought was being a bit up in arms about what a sexist company you are. Then I looked at your site, and well, I doubt that the purpose of your company is to oppress anyone, but it is, well, if not sexist, just plain stupid.

As I am not a woman, I suppose I am less personally offended by the caption "Rip Me, Mix Me, Play Me ALL NIGHT LONG." Because I suppose the idea of being "played" and "ripped" is less a personal threat. Still, I think "ripping" a woman is not something you might want to lightly toss out. The most well known idea of a woman being "ripped" that I can think of refers to Jack the Ripper. If you have some sort of double entendre that isn't so much violent sex crime oriented, let me know.

But anyway, like I said, it's not the violent rape connection to your product that personally offends me, so much as the visual. See, I am an artist and think visually, and while I like half naked women as much as the next (straight) guy (well, for that matter, lesbian) I like them in certain contexts. Bedrooms, bathtubs, things like that. If you were selling panties or something for backrubs, fine, I could see the connection with a topless model, but I dunno, man, I really don't want to connect electronics with sex quite that much. I mean, is this really the sort of associations YOU want to make?

But still I digress. Here's the really stupid thing- the model, random and unconnected with anything else in the site, is wearing panties and high heels. Obviously you guys must watch porn and beauty pageants a lot, because in real life, this is not an ensemble that anyone would wear. Again, prove me wrong if you can, but I betcha that your mom didn't make Rice Krispy Treats in pumps with her boobs hanging out for all to see.

Please respond.

Rich Mackin

P.S. In case you don't think you are sexist, why not put a picture of some guy wearing tighty whiteys and dress shoes on the site?

NO REPLY!

 AHA! This is not a letter! It is a printed out email! I think that counts. While they did not reply to this, they were nice enough to spam me for a few months with sale updates. They did remove the image in question.

May 15, 2002

Dear Taco Bell.

I live on Commonwealth Avenue in Boston, which means that almost daily I ride the bus, subway, or my bike past an army of Boston University kids, block after block of B.U. buildings, including a few dorms. One dorm has a Taco Bell in it. This Taco Bell has a sign in it that says,

"Winners Eat Steak."

Here are my questions, at least those off the top of my head,

1) What did they win?

2) If they won a steak eating contest, wouldn't the losers eat steak, too?

3) Are you calling the people who eat chicken and bean and cheese tacos losers? Is that the way you think you are going to drive up the higher end products? With SHAME? Well, shame on YOU!

4) If the winners won a vegetarian cooking contest, they wouldn't be eating steak at all.

5) If the winner was the best cow in a county fair, and that cow ate steak, that cow would probably get Mad Cow Disease, which would not only be sad for her, but then the cow's owners would have to sue Oprah Winfrey instead of deal with the fact that they messed up by feeding a cow steak , which is why she got sick and why Oprah doesn't want to eat her.

6) Wouldn't a better slogan be "Winners Eat Tacos?"

Please Respond,

Rich Mackin
POBox 890
Allston, MA 02134

NO REPLY!

126

Dear Crest

Brushing my teeth just isn't as fun as I seem to recall it being. For a while now, I have been trying to figure out why, and it dawned upon me.

When I was a kid, I wasn't merely brushing, I was fighting the Cavity Creeps, the horrible creatures that seemed to be made of stone of some kind, using gruff mannerisms and primitive weapons to destroy Toothapolis. While Toothapolis was shown to be a Utopian society of ethnic diversity and dental hygiene, it also was clearly a metaphor (not that I knew what a metaphor was at the time) for my own teeth. When I brushed, I knew not that plaque buildup was related to tartar and gingivitis. I wasn't concerned about whitening formulas and I sure as hell would never equate baking soda and brushing. I was waging a war! I was defending my turf against a siege of enamel-thirsty cretins intent on destroying all I have worked so hard for.

And now, when I brush, I am merely instinctively removing plaque and tartar, fighting morning breath, and easing the guilt I surely feel in the dentist chair.

So Crest, I turn to you. Is there any way you can renew my fervent emotions?

Please, do what you can.

Rich Mackin
POBox 890
Allston MA 02134

127

P&G

**External
Relations**

The Procter & Gamble Company
General Offices
1 P&G Plaza
Cincinnati, Ohio 45202-3315
www.pg.com

Our ref: 5314507
October 22, 2002

MS RICH MACKIN
PO BOX 890
ALLSTON MA 02134

Dear Ms. Mackin:

Thanks for contacting Crest. I knew something had been missing for me to, but didn't know what until I read your letter! Isn't it amazing how so many things were much more fun as a kid!

Well, your timing couldn't have been better! We have a brand spanking new Crest that is sure to bring back all the energy you once felt when fighting those Cavity Creeps! It's called Crest Rejuvenating Effects. Rejuvenating Effects helps remineralize, refresh and restore your teeth and gums! Not to mention it has an awesome flavor. Hope you'll give it a try!

Sincerely,

Mary Smith

Mary Smith
Consumer Relations - FH

For Office Use Only:
1 CO 009170
1 OE 009001

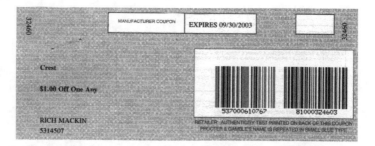

Frito Lay
Plano TX 75024-4099

Feb 19, 2003

Dear Lay's Potato Chips

I was looking at yet another of your bags of chips and on the back it said,

"Our founder, Herman W. Lay, believed in selling only the highest quality potato chips."

But seeing how your company is called Frito-Lay, then that must mean that you have TWO founders. Now that I have some insight of Lay's personality and thoughts, can you tell me somewhat of Mr. or Ms. Frito and what (s)he might have thought about quality?

Or is the fact that this Frito person isn't being quoted a sign that they were the business end of the pair, while Lay was the artist- the soul, Frito might have been the hard driving task master who turned this chip company into a corporate empire?

Please Respond

Richard Carman
43 North Bridge St
East Norwalk, CT 02134

NO REPLY!

Feb 22, 2003

Dear FDS

I was watching television with my mother in the living room and on the television was an advertisement for your product FDS. It did not actually say what I am supposed to do with your product, but the end result was that if I were to use FDS I would be able to, as you put it

"Stay Fresh All Day Long."

According to Dictionary.com, the word fresh has some of the following definitions...

1. New to one's experience; not encountered before.
2. Novel; different: *a fresh slant on the problem*
3. Recently made, produced, or harvested; not stale or spoiled:
4. Not preserved, as by canning, smoking, or freezing
5. Not saline or salty: *fresh water.*
6. Not yet used or soiled; clean: *a fresh sheet of paper.*
7. Free from impurity or pollution; pure: *fresh air.*
8. Additional; new
9. Bright and clear; not dull or faded
10. Having the glowing, unspoiled appearance of youth
11. Untried; inexperienced
12. Having just arrived; straight
13. Revived or reinvigorated; refreshed
14. Fairly strong; brisk
15. *Informal.* Bold and saucy; impudent.
16. Having recently calved and therefore with milk. Used of a cow.
17. *Slang.* Excellent; first-rate.

As I recall from watching motion pictures such as "Breakin'" and "Breakin 2, The Electric Boogaloo." the term "fresh" meant that something was good, desirable, and held in high esteem with those knowledgeable with the current fashions and trends, which I believe is in keeping with the last definition. (I doubt that there is a need to make someone non saline- am I wrong?) Surely, I would like to be excellent and first rate all day long. However, my mother was very clear that I in actuality did NOT want this product, but was hesitant to explain why.

As the manufacturer of the product, and thereby those responsible for this advertisement, can you provide some insight into your product, how it would make and keep me fresh and furthermore, why my mother seems so secretive about this matter?

Thank you

Richard Carman
43 N. Bridge St.
East Norwalk, CT 06855

NO REPLY!

130

Feb 26, 2003

George W Bush
The White House
1600 Pennsylvania Ave NW
Washington DC

Dear George,

What's the deal with Beef Jerky? I mean, not so much as what is it, but why is America so INTO it? Have you ever been at a rest stop mini mart? It's like there is a whole aisle of nothing but beef jerky! Like, there is as much jerky as there are chips of all sorts...there will be a chip aisle, a candy aisle, a hardware/ auto parts aisle, and a whole aisle of JUST jerky. I mean, how much variety can there be to warrant so much space? I was gonna write to some mini mart companies, but I figured since you ran the whole country you might be able to give me a more all in all answer instead of speaking for just one place.

Thanks

Rich Mackin
POBox 890
Allston, MA 02134

NO REPLY!

Feb 27, 2003

Dear Wal Mart

No! No! No!

You got it all wrong! In fact, you got it EXACTLY wrong. I wrote to you about a year ago to point out that you, a huge corporation run by one of the wealthiest men in America, that drives small businesses OUT of business, and ruins economies of entire town, should not use Zorro, or even a smiley face dressed as Zorro, as a logo. In this letter, I also mentioned that Robin Hood would also be a bad spokesman. (Or spokesmiley, for that matter.)

So, I just turn on TV, and there is a Walmart ad, with the smiley dressed as Robin Hood! What the heck! Do you guys do ANY research? Much as Zorro defended peasants from wealthy landowners (ie- Walmart being a wealthy landowner.) Robin Hood STOLE from the rich (ie- you) and gave to the POOR (ie- the people who get put out of business by you.) In any case, he surely would be spending a lot of time sacking Sam Walton's house if he had the chance.

This would be like if the Catholic Church started making ads with Martin Luther as spokesman, in yellow smiley form or not. Or some tech company using the Unabomber or something.

Geez, I am not even asking you to stop being evil, just to stop being hypocritical about it.

Thank you

Rich Mackin
POBox 890
Allston, MA 02134

NO REPLY!

132

Dear Nuprin

Here is a haiku.

Little, and yellow,
And don't forget different
Headache gone- NUPRIN!

Enjoy,

NO REPLY!

Rich Mackin
POBox 890
Allston MA 02134

27 February, 2003

Dear Maybelline

I just saw your commercial on TV where you are advertising the new
super wet gloss lipstick product with "diamond shine" or such and at the
end of the ad there is your signature tagline...
"Maybe she's born with it, maybe it's Maybeline."

Due to the fact that no woman has neon pink glossy lips with sparkles on
them, I think it's safe to say that there is no maybe involved with this
case.

Cheryl Carman
43 North Bridge St
East Norwalk, CT 06855

NO REPLY!

Sept 11,

Republican National Committee
310 First Street, SE
Washington, DC 20003

Dear Republicans,

I just read (original source, the Chicago Sun Times) about Connie Peters, the Illinois based Republican activist who gets paid $23,000 a year to "observe" bimonthly water management meetings.

How would I go about getting a job such as this? I would prefer to Stay in Boston, but would relocate if need be. I can provide a resume and references if need be.

Rich Mackin
POBox 890
Allston MA 02134

NO REPLY!

134

Feb 28, 2003

Dear Cup-a-soup

I am looking at the packet for your Spring vegetable soup, and I notice that while you endorse this product as "A starter before a meal" or any number of "snack" options, you also endorse "a great time" for it to be "while skiing, hiking or during any other outdoor activity."

Considering that preparing your product involves boiling water, and that many outdoor activities (such as skiing) are fast paced and involve needing both hands, are you sure that these are "great times" to use your product? It seems that while the product name is Spring Vegetable, the recipe is for disaster.

Thank you

Richard Carman
43 North Bridge St
East Norwalk, CT 06855

March 24, 2003

RICHARD CARMAN nmc 6490021-1012123
43 N. BIRDGE ST.
EAST NORWALK, CT 06855

Dear Mr. Carman:

Thank you for taking the time to contact us. We appreciate the opportunity to respond to you.

We try to assist our consumers whenever possible and hope you enjoy the enclosed as a token of our appreciation. If you have any additional questions or comments, please call us at our toll-free number or visit our website at www.unilever.com.

Sincerely,

Chris Green

Chris Green
Consumer Service Representative

Fans of my Lever 2000 series may recognize
Chris Green's name.

135

March 10, 2003

Parking Clerk
Town of Brookline
P.O.Box 470708
Brookline, MA 02447-0708

To whom it may concern,

On Friday, March 7, 2003, I parked my car in the public parking lot behind the Coolidge Corner Theatre to attend the "midnight" showing of the film Donnie Darko. In actuality, the film started somewhat after midnight, thus making the rest of these events occur in the earliest moments of Saturday, March 8, 2003. I had no way of knowing that the film would not let out until about 2:10- 2:15, thus causing me to get to my car AFTER it had been decreed to be parked "overnight" at 2:10 am.

As I don't see how parking in the lot seemingly provided for patrons of a movie theatre until the end of a movie, at which point I promptly left, is to be considered "overnight" parking, or a parking violation of any kind, I ask that this ticket not be enforced, and that I not be expected to pay a fine for using the parking lot for exactly what it seems meant to be used for.

Enclosed is a testimonial from the manager-on-duty of the Coolidge at the time of the ticket. If need be, I can provide further notice from the people I saw the film with, other employees working at the time of the ticketing, and those who saw me at the residence I slept that night, thus confirming that my car was not at all parked "overnight"

Thank you

Rich Mackin
currently residing at
43 North Bridge St
East Norwalk, CT 06855

136

COOLIDGE

March 9, 2003

To Whom It May Concern:

On Friday, March 7, 2003 Rev. Richard J. Mackin was in fact present for the duration of the film Donnie Darko (2000, 120min. dir. Richard Kelly.) I bore witness to his presence. He left promptly after the film let out, at approx. 2:15, and proceeded to leave to his domicile via the automobile in question. Richard is a frequent customer at our movie theatre, and has never displayed desire to stay overnight in the parking lot, or over stay his welcome. Due to past film going precedent, I can, in good faith object to the assumption that he or his car were to be staying the night in said parking lot.

Richard is a nice boy who always cleans up his popcorn and trash.

Thank you for your consideration,

Jillian Maryonovich
Staff Manager
Coolidge Corner Theatre

Coolidge Corner Theatre Foundation
290 Harvard Street, Brookline, Massachusetts 02446 • tel: (617) 734-2501 • fax: (617) 734-6288 • www.Coolidge.Org
a not for profit corporation

TOWN of BROOKLINE
Massachusetts

Parking Clerk
P.O.Box 470708
Brookline, MA 02447

Violation/s: 3100228

Violation Date/s: 3-8-03

Date Rec'd: 3-13-03

Date Rev'd: 3/23

> Rich Mackin
> 43 North Bridge St.
> East Norwalk, Ct. 06855

The parking ticket/s listed above, the validity of which you have challenged by mail, have been reviewed by the Hearing Officer along with any related evidence submitted by you. After such review the ticket/s have been:

- [✓] Dismissed
- [] Fine Mitigated to $_____ due by _____
- [] Upheld for the following reason/s:

- [] Lack of signed statement by operator.
- [] Lack of ticket number and/or date of violation.
- [] Lack of sufficient and credible evidence that ticket/s were not validly issued.
- [] Other_____

If you wish to have a hearing in person before the Hearing Officer on this matter, appear during the hearing hours listed below within twenty-one days of the Review Date with the parking ticket and any appropriate evidence. No appointment is necessary. This form must be presented to the Hearing Officer at the time of the hearing.

_____HEARING SCHEDULE_____

Hearings are held in the offices of the Brookline Police Traffic Division, 350 Washington Street, Brookline, as follows:

Monday & Wednesday evenings 5:00 PM to 7:00 PM

Tuesday & Saturday mornings 9:00 AM to 11:30AM.

Please note that hearings are NOT held on holidays and the eve of major holidays.

Hearing Officer
Office of the Parking Clerk

138

March 10, 2003

Triscuit
c/o Nabisco
East Hanover, NJ 07936

To whom it may concern,

Hello and good day. I hope this letter finds you well. I am writing because I have two questions.

First of all, what does Triscuit mean, exactly? I can guess that the similarity to the word "biscuit" is more than coincidental, but it invokes the idea of a tri-biscuit, some form of triple biscuit. Is this indeed the case, or is there another explanation?

Secondly, I see that one of your ingredients is something called "partially hydrogenated soybean oil". While I have a general idea of what soybean oil is, I would appreciate some explanation of what hydrogenating means, and why it is only done partially, possibly what the percentage of the partiality (if that is a word) that is done.

Thank you for your time.

R. J. Carman
43 N. Bridge St
East Norwalk, CT 06855

Consumer Resource & Information Center

March 21, 2003

Mr. R. J. Carman
43 N Bridge St
Norwalk, CT 06855-1404

Dear Mr. Carman,

I'm happy you took time out of your busy schedule to contact us. Enclosed please find the item you requested.

Hydrogenated {hydro-jen-a-ted} vegetable oils get their name from a chemical process called hydrogenation. This process of adding hydrogen converts unsaturated vegetable oil, which is liquid at room temperature, to a more solid more saturated vegetable oil. Hydrogenated oils are used because they are more stable which helps to ensure the quality of a product throughout its shelf life. Hrdrogenated oils are generally used in small amounts in products. As with all fat-containing ingredients in our products, the fat content of this ingredient is factored into the "total fat" declaration on the Nutrition Facts panel. Products containing hydrogenated oils can be part of a nutritious diet if the fat content of one's total diet is within the current guidelines.

Let me know if there is anything else I can do for you in the future.

Sincerely,

Kim McMiller
Consumer Resource Manager
Ref: 4618854

Kraft Foods

KRAFT FOODS One Kraft Court Glenview, Illinois 60025 • (800) 323-0768
For Food & Family Ideas Visit Our Website at www.kraftanswers.com

March 11, 2003

Triscuit
c/o Nabisco
East Hanover, NJ 07936

I don't know exactly what your problem with Nibblers is, but I do know that it is very offensive that you blatantly label your product as NOT for Nibblers. I would like to think that in this day of age that our society has moved beyond segregation. I cannot believe you would dare to dictate your clientele. I await an apology and retraction.

Rich Mackin
POBox 890
Allston, MA 02134

Consumer Resource & Information Center

April 2, 2003

Mr. Rich Mackin
PO Box 890
Allston, MA 02134-0006

Dear Mr. Mackin,

Thanks for getting in touch with us about advertising for our products. I'm glad you thought enough of us to share your comments.

We consider our advertising as our company's voice to the public and to consumers like you. It concerns us when one of our consumers expresses disappointment with an advertising campaign. With so many different audiences viewing our advertising and forming a wide range of opinions, it's hard to create advertising that makes everyone happy. For the most part, consumers reaction to our commercials and print advertising has been positive.

We always want to hear what you're thinking. Even though I can't promise we won't use this ad anymore, I want you to know I've shared your opinions with our marketing and advertising teams. Remember, food brings us together and together we can make something good!

Sincerely,

Kim McMiller
Consumer Resource Manager
Ref: 4677882N

KRAFT FOODS One Kraft Court Glenview, Illinois 60025 • (800) 323-0768
For Food & Family Ideas Visit Our Website at www.kraftanswers.com

142

March 11, 2003

P-F Unlimited, Inc.
4510 South 86th East Avenue
Tulsa, Oklahoma 74145

Dear P-F Unlimited.

I am writing to you concerning your ad for funeral directors and possibly related professionals for your speedily delivered "incredible, brown-sugar glazed, spiral-carved Sara Lee ham" which you claim to be "the perfect answer to showing the family you care." Then, in a bit of lax grammar, you mention "And, the personalized box is sturdy enough and so beautiful that the family will want to keep it to store keepsake items." The box in question says, "Our deepest Sympathy to You and Your Family during this time of Grief." This statement, of course, being exactly the sort of sentiment they want to proudly display on a container of collectibles.

To some extent, I wonder if you consider at all if the family is vegetarian or keeps Kosher, but specifically, I am writing because I am somewhat concerned that somewhere in our society there are people that think that dead flesh in a box is the best way for a funeral home to commemorate someone dying and being put in a box.

I await your response

Sincerely

R. John Mackin
43 N.Bridge St.
East Norwalk, CT 06855

Judy Robinson

Mr. Mackin -

We are in receipt of your letter dated March 11, 2003, regarding our Ham program.

We offer a variety of programs for the funeral industry. We also offer a cheesecake in a Keepsake box. The box is being used by the funeral homes to explain to the family

it might be kept to store important papers & documents, not as a "proudly displayed Collectible".

We have sold thousands of hams to the funeral industry. We are very sorry you did not like our ad. Thank you for taking the time to contact us, and we wish you well with your marketing plans. Judy Robinson

March 11, 2003

Swiss Miss
C/o ConAgra Foods
Irvine, CA 92619

Dear Swiss Miss

While enjoying a package of Swiss Miss brand hot cocoa, the version that has No Sugar Added and is with calcium, It occurred to me that since the package proudly displayed some information about the ingredients, I should look at the full ingredient list. This is what prompter me to write to you. For one thing, I am curious about what partially hydrogenated soybean oil is. What is hydrogenation, and why is it a partial process? What exactly are maltodextrin, dipotassium phosphate, and polysorbate 60?

But I must say that the thing I am most curious about is Modified Whey. Not for the whey part, but for the modified part. The *The American Heritage® Dictionary of the English Language* definitions of modified are...

1. To change in form or character; alter.
2. To make less extreme, severe, or strong
3. *Grammar.* To qualify or limit the meaning of. For example, *summer* modifies *day* in the phrase *a summer day.*
4. *Linguistics.* To change (a vowel) by umlaut.

To consider the first definition, alter like in science fiction mutant way, or what? Like *Altered States?*

To consider the second, how is whey severe, and what would you do to weaken it?

To consider the third, how would the whey be qualified or specific. If this is a certain kind of whey, why not say what kind.

To consider the fourth, whey with an umlaut would make it more rock and roll I suppose, which would be cool. If nothing else, I am glad I looked at your box because now I can say that Metal Bands MODIFY their names.

In any case, I would appreciate some clarification,

Thank You

R.J. Carman
43 North Bridge St
East Norwalk, CT 06855

NO REPLY!

145

March 12, 2003

City of Boston
P O Box 2288
Boston, MA 02107-2288

Dear Parking Clerk.

I went to my car the other day and saw that I had a ticket, clearly it was just placed on my car by the officer not 10 feet away. I went to see why I had gotten a ticket, and then noted that apparently my timing was just a few minutes off, and that my meter had run out because I took a few minutes longer than I estimated. This is irksome that 5 minutes cost me $25, but well, there you go, sometimes life isn't fair.

BUT, I bet I am the first person, at least in a while, who admits that I had my chance and blew it, and have nobody to blame but myself.

Have a good day.

Rich Mackin
POBox 890
Allston, MA 02134

NO REPLY!

March 12, 2003

JetBlue Airways
P.O. Box 17435
Salt Lake City, UT 84117-7435

Dear JetBlue Airlines

After watching your television commercial, I now know that you have leather seats. Which is worth noting, because I don't really think that flying thousands of feet in the air at amazingly high speeds just is the same unless my ass is resting on the skin of a dead animal.

Thank you

Rich Mackin
POBox 890
Allston, MA 02134

NO REPLY!

March 18, 2003

Portion Pac Inc
Mason Ohio 45040

To the makers of Taste Pleasers Gourmet Mild Sweet & Sour Sauce,

May I just ask what you were thinking when you came up with your ingredients list? See, normally, I would make comments about the irony of having both High Fructose Corn Syrup and Corn Syrup, what "Modified" food starch means, what sort of "Natural Flavors" these are, etc. But all of these questions pale in comparison to the one word that screams from the near bottom...

ANCHOVIES

WHY would you put anchovies in a condiment? Except for the possibility that you hate vegetarians a lot and want to sabotage them when they assume that a sauce won't have dead fish in it, neither I nor any of the twenty people I have run this by have any idea of the logic you might be using or what you might think you stand to gain

Please respond

Rich Mackin
POBox 890
Allston, MA 02134

PORTIONPAC *Division of H.J. Heinz Company L.P.*
Product. Packaging. Innovation.™

May 19, 2003

Rich Mackin
P.O. Box 14642
Portland, OR 97293-0642

Dear Mr. Mackin,

Thank you for writing to Portion Pac. We were sorry to learn that your use of Taste Pleaser's Gourmet Mild Sweet and Sour Sauce fell short of your expectations.

Upon investigation, I discovered that our old ingredient statement for Taste Pleaser's Gourmet Sweet and Sour Sauce used to contain the ingredient anchovies. However, the ingredient statement has been revised and the product will no longer contain anchovies.

Once again, please accept our apologies and our thanks for providing important information. We hope that your future experiences with our product will be positive and that you will enjoy it with complete confidence and satisfaction. If you have any further questions or concerns, please do not hesitate to contact us.

Sincerely,

Portion Pac

7325 SNIDER ROAD

MASON, OHIO 45040 U S A

513.398.0400 phone

513.459.5300 fax

3/18/03

Dear Curel

Your ad starts with the words "tired of shaving" and mentions how with
Curel, "you" can shave half as often. I assume that the "you" refers to leg
shavers, which seems mostly directed to women.

The question that I put to you is, if women are tired of shaving, shouldn't
they stop shaving? I mean, what harm would befall the world if suddenly
all women grew out their leg hair and walked on their hairy legs proudly
and naturally? If anything, wouldn't the world be a cleaner and safer
place, with that many less disposable products taking space in landfills
and that many less cuts and related injuries?

I mean sure, when it first happens, if you consider American mainstream
culture and the standard male-female relationship, there will be a brief
period when some men will think it's a bit gross and "unfeminine" but you
know, I bet you my bank account that if average American straight men
had the choice of hairy legged women or none at all, I think we would all
get used to the idea REAL quick.

The shaving thing is a specific point because of your specific product's
point, but in general, don't you find it odd that your product is advertised
as a partial solution to a problem that would be better off solved entirely
without you?

I await your response.

Rich Mackin
POBox 890
Allston MA 02134

NO REPLY!

149

March 18, 2003

Charms LP
Covington, TN 38019

Dear Charms

After I downed an entire bag of Charms Fluffy Stuff (Snow Balls) Cotton Candy, it was brought to my attention that normally I try and eat food that is better for me, or at least food that counts as food. The ingredients were shown to me to indicate that your product really isn't food so much as sugar with chemicals (ie- artificial flavor and color.)

Here's the thing though, clearly, if I was worried about the artificial thing, I just wouldn't eat your product. It's the color thing. You have FD&C Blue 1, Red 40, and Yellows 5 and 6. And yet the end result of adding all this color to sugar is that it is now white. Do I need to spell out my confusion any further?

Please Respond.

Rich Mackin
POBox 890
Allston MA 02134

CHARMS COMPANY

7401 SOUTH CICERO AVENUE • CHICAGO, ILLINOIS 60629

TEL. (773) 838-3400
FAX (773) 838-3534

April 16, 2003

Rich Mackin
P.O. Box 890
Allston, Massachusetts 02134

Dear Rich:

Thank you for contacting our company. We appreciate when our consumers take time to address us with their questions and concerns.

Snow Balls are produced on the same equipment as our regular Fluffy Stuff Cotton Candy which may contain FD&C Blue 1, Red 40, Yellow 5 and Yellow 6. The FDA expects the manufacturer to label for FD&C colors even if they are at trace level. In order to address the potential of cross contamination, even at a non-detectable level, we made the decision to label for FD&C colors, whether or not they are used, which they are not in Snow Balls.

We hope we have been of assistance to you in this matter and we thank you again for your interest.

Sincerely,

THE CHARMS COMPANY

Janet M. Vasilenko
Consumer Relations
Administrator

151

December 18, 2000

Mr. Rich Mackin
P.O. Box 890
Boston, MA 02134

Dear Mr. Mackin,

I appreciate that you took the time to contact us. Unfortunately, the product you've referenced isn't manufactured by our company.

I don't have any information to share with you about this product but would like to offer a suggestion. The name of the company that manufactures the product should appear on the packaging or label. Sometimes there will also be an address and maybe a phone number.

I'm sorry I can't help you further but would certainly encourage you to check the product packaging for an address. I'm sure the company that makes this product would be interested in hearing from you.

Sincerely,

Kim McMiller
Consumer Resource Manager

8367197/10180544/KAC/kgf

One of the problems with writing as many letters to as many companies as I do, is that this sort of letter comes to point out a mistake I must have made...and yet I have little to no idea of what product I was referring to was.

Kraft Foods

KRAFT FOODS One Kraft Court Glenview, Illinois 60025 • (800) 323-0768
For Food & Family Ideas Visit Our Website at www.kraftanswers.com

152

July 25,1995

Dear Star Market,

Today I bought a container of Star Market Iced Tea mix. I bought
it under the assumption that I could OPEN this container and
use it's contents. Furthermore, I was foolish enough to assume
that I would be able to use the container to store the unused
mix. Well, we both know that when you ASSUME you make an ASS
out of YOU and ME. Apparently your Iced Tea has some cryptic
function far beyond my narrowminded view of how Iced Tea should
be used. See, I tried to OPEN the can. Get right out you say,
but nope, I'm staying. I tried to open the can with -get this-
a CAN OPENER. When it (the can opener) broke, I tried another
one. After 15 minutes, I managed to wrangle most of the top
off, bringing with it the rim that I was silly enough to assume
should stay on the container. I finally had to pour the Iced
Tea mix in a different container.

So here is my question- since your Iced Tea is obviously not
meant for mixture and drinking, what IS is supposed to be used
for? I am intrigued. Please let me know.

Richard J. Mackin
1191 Boylston St #33
Boston, MA 02215

STAR MARKETS

August 8 , 1995

Mr. Richard J. Mackin
1191 Boylston Street #33
Boston, MA 02215

Dear Mr. Mackin,

We are sorry to learn of the problem you encountered with the packaging of Star Ice Tea Mix.

We have notified our supplier, Sturm Co., of your dis-satisfaction with their product and have instructed them to contact you to explain what caused the problem and what they plan to do to correct it.

Again, we apologize and hope that you'll accept the enclosed gift certificate with our thanks for your taking the time to let us know of this problem and also to reimburse you for the product.

Please do not hesitate to contact me at 617-661-2267 if I can be of any further service to you in this or any other matter.

Sincerely,

Mary Fielding

Mary Fielding
Grocery Division

Star Markets Company, Inc., 625 Mount Auburn Street, Cambridge, MA 02138, 617-661-2200

156

Star Market
Cambridge, MA 02138

Dear Star Market,

After my unfortunate experience with Star Iced Tea MIX, I thought
I would give Star Market ready made ice tea a shot. It did taste
good, and I noticed the unusual flavor resulting from the fact
that it was sweetened with lemon. Mind you, it did not say that
it was sweetened , with lemon but sweetened-with-lemon, which
intregues me sinse lemons are regarded as sour and not sweet
at all. Furthermore, after reading the ingredients, I would
think that it would be more accurately called "sweetened with
corn syrup" without any lemony reference since there is no lemon
cited.

I also would like my money back. I appreciate having this
opportunity to get my money back for no reason, when most
products give refunds for complaints. But when I read the

"MONEY BACK GUARANTEE if you write to us about the product,
please include the code printed or embossed on the package and
the bar code numbers" No mention of conditions leading to money
back. Some numbers printed are 70-4158-820, four times in
different colors at the top. 7-11535-10235-9 immediately after
and bar code # 11535 10235.

Thanks,

Rich MAckin
1290 Comm AVe #4
Allston MA 02134

P.S. Did you chose the name STAR MARKET in order to hear
Bostonians pronounce it funny?

July 8, 1996

Mr. Rich Mackin
1298 Commonwealth Avenue - #4
Allston, MA 02134

Dear Mr. Mackin,

Thank you for your recent letter regarding Star Ice Tea Mix.

I have passed on your comments to the manufacturer of the Ice Tea and have instructed them to contact you to explain their use of ingredients in the product. You should expect to hear from them in the very near future.

We hope you will accept the enclosed gift certificate along with our thanks for taking the time to write. Please do not hesitate to contact me at 617-528-2700 if I can be of any assistance in this or any other matter.

Sincerely,

Mary Fielding

Mary Fielding
Star Grocery Division

Star Markets Company, Inc., 625 Mt. Auburn Street, Cambridge, MA 02138, 617-528-2500

158

JOHANNA
FOODS, INC.

July 26, 1996

Mr. Rich Mackin
1298 Comm Avenue #4
Allston, MA 02134

Dear Mr. Mackin,

In response to a problem you experienced with a product we process, Star Market Iced Tea, please accept my sincere apology for any inconvenience the problem may have caused you. We take great pride in our products and are very concerned when a consumer expresses dissatisfaction.

We value your patronage and appreciate your concern in reporting this incident. We are enclosing a reimbursement check for the unused portion of your iced tea. We are confident that future purchases of our products will meet with your complete satisfaction.

If I can be of any further assistance please do not hesitate to contact me.

Sincerely,

JOHANNA FOODS, INC.

Karen Christiano
Consumer Affairs
Aseptic/Juice Divisions

cc: J. Cohen (Johanna)
 H. Snyder (Johanna)
 K. Danielson (Daymon)

Dear Star Market

After several scarring psychologically and one physically
attempts to open your cans of Iced Tea mix, I had abandoned
the idea of your Iced Tea mix altogether. (by the way, i did
indeed cut myself of a can, and could have been a cry baby and
sued you like the McDonalds coffee thing.) But I had been craving
the stuff,and when I saw the HUGE container with enough mix
to make over SIX GALLONS of it, I said to heck with it and bought
the thing. I took it home, I put it on the lectric can opener
that opens soup and veggie cans lickedy split, and the thing
wouldn't open. I attempted with a manual can opener, but only
sections would become unlodged. I finally ripped the whole top
off (see enclose photo.) I want to know, what is the concept
here? Why can't you be like any normal product and have a
container that can be opened. Childproof containers are easier
to open. Rat poison is easier to get at than Iced tea mix. What
the hell is wrong with you? And what the hell is wrong with
me for buying the stuff again and again?

Please Respond.

Richard J. Mackin
1298 Commonwealth Ave #4
Allston MA 02134

160

STAR MARKET

October 18, 1996

Mr. Richard Mackin
1298 Commonwealth Avenue #4
Allston, MA 02134

Dear Mr. Mackin,

We are sorry to learn of the problem you recently encountered with Star Ice Tea Mix.

We have notified the supplier of the product and have directed them to contact you to explain what caused the problem. We have also instructed them to take whatever precautions are necessary to ensure there is no repetition of this.

Please accept the enclosed gift certificates to reimburse you for the product and to apologize for any inconvenience this has caused. We also want to thank you for taking the time to write to make us aware of the problems.

Do not hesitate to contact me at 617-528-2700 if I can be of any further assistance in this or any other matter.

Sincerely,

Mary Fielding

Mary Fielding
Non-Perishable Merchandising Division

Star Markets Company, Inc., 625 Mt. Auburn Street, Cambridge, MA 02138, 617-528-2500

TOPCO ASSOCIATES, INC. World Brands, Inc. KINGSTON MARKETING CO.

7711 GROSS POINT ROAD • SKOKIE, IL 60077-2697 • (847) 676-3030 • FAX (847) 673-6352

October 21, 1996

Mr. Richard Mackin
1298 Commonwealth Ave. #4
Allston, MA 02134

Dear Mr. Mackin:

Thank you for your report to Star Markets about the iced tea mix.
We are sorry that you were not pleased with this product, and we
appreciate your letting us know about it.

We have informed the manufacturers of the product of your
comments and asked them to respond directly to you. We have also
given your report to our Quality Assurance department for their
information.

We appreciate your interest in our products and thank you for
taking the time to contact us.

Sincerely,

Patricia Gardner

Patricia Gardner
Senior Consumer Services Representative
Quality Assurance

PG/pp
cc: Jim McInnis/ST

EGGS
BUTTER
MILK

A. STURM & SONS INC.

WHOLESALE PRODUCE
"LIGHTNING SERVICE"

SEED
SUGAR
TWINE

AREA CODE 414
PHONE 596-2511

TWX 9102721100
STURMINC MANW

P.O. BOX 287
MANAWA, WI 54949

December 17, 1996

Mr. Richard Macklin
1298 Commonwealth Ave. #4
Allston, MA 02134

Dear Mr. Macklin:

We have been informed that you had trouble opening various cans of Star Iced Tea Mix. As the manufacturer of this product, please accept our apologies for the concern and inconvenience you have experienced.

On occasion we have found if a can lid is not scored deep enough or is scored too deep, it will be difficult to open. This condition is usually noticed and the lids are discarded. We will let our supplier know about your experience so he can recommend appropriate measures to prevent future reoccurrences.

We mainly use a hand-held can opener (swing-away brand), however, we also will use an electric can opener. I would recommend using the hand-held style opener on the 64 oz. can. It's just much easier to handle all the way around. As you know, once the lid has been damaged it's difficult to get another opener to effectively open the can.

Again, our apologies to you. We try to provide our customers with a quality product at all times. We regret that the packaging material did not meet the same standards. Please accept the replacement 64 oz. can of Star Iced Tea Mix that will be sent to you under separate cover. We hope this product will meet with your approval and you will continue to use it in the future.

Sincerely,

A. STURM & SONS, INC.

Nancy Oman
Q.C. Supervisor

NO/bjc
cc: Patricia Gardner
 Jack Sturm
 Dick Droste

163

Jan 8, 1997

Dear Everyone who is involved with Star Market Iced Tea Mix...

WHAT THE HELL IS WRONG WITH YOU?

I write to you a few times regarding Star Iced Tea Mix and my
recurring problems opening the container. I still buy the stuff
because it is a good bargain, and a relatively environmentally.
physically, and economically harmless product. You are upset
that a customer has a complaint. You are worried about my tale
of blood spilt on poorly constructed cannisters and fear lawsuit
perhaps. You set into action...

I recieve phone calls (despite not giving you my number) and
letters from Star Market employees of all kinds. Letters from
Distributors, Manufacturers, container makers, ingredient makers,
wives, girlfriends, mothers, neighbors, people that once
considered working for the makers of Star Market Iced Tea.

You give me gift certificates, coupons, apologies, thank yous,
advice on can opening, and finally a free replacment THROUGH
THE MAIL! You are so considerate that you don't want me to have
to go to the store to redeem a coupon and carry it hope, a GUY
BROUGHT IT TO ME! We shook hands!

I was left alone with the new can of Iced Tea Mix. It was awe
inspiring. Bold new packaging with the familiar mirror like
metal top. I waiting for my girlfriend to arrive so she could
share as I partake not only in iced tea, but in consumerism,
of fairness, of "the customer is always right"ness, of-if I
dare say- AMERICA. I take a HAND HELD (as recommended by at
least some of you) can opener and make the initial incision,
with no more or less wonder than a surgeon in a similar
situation. The first crack causes the can to hiss "FRESSSSHHHHH"
as the sealed air is released. I start to work the opener, and
the thing fails. If it were a car, it would sputter. I try again,
and thrice, but to no avail. I give up on manual and try for
the trusty electric opener, which has opened jillions of soup
cans with nary a problem, and it begins to cut open the lid,
only to spasm and leave gaps. After several rotations with no
better results, I press the can slightly aginst the blade. The
metal tears from the cardboard sligtly, so I stop, only to use
a "church key" to open a big hole in the thing and dump it in
the old Star Iced Tea Cannestar that I was saving for sentimental
reasons.

After all that, you still can't make the container right? What
are you going to try to appease me with this time? Have someone
come over and open my Iced Tea Mix FOR me? Maybe sending one
of the Openers that YOU use. I would like to ask advice of peers,
but all my friends are snobs and insist on buying brand names.
Please help. Iced Tea mix should not occupy this much of my
life.

Thank You

Richard J. Mackin
1298 Commonwealth Ave #4
Alston MA 02134

164

Daymon Associates/Star Brands
Jim McInnis
625 Mt. Auburn St.
Cambridge, MA. 02138

January 20,1997

Richard J. Mackin
1298 Commonwealth Ave. # 4
Allston, MA. 02134

Dear Mr. Mackin,

This letter is to assure you that your efforts / suggestions are not falling on deaf ears. After receiving your first letter, regarding the difficulty opening the Star Iced Tea Mix, Star has decided to incur the additional expense of incorporating the "Flip Top" type lid which will eliminate the use of a can opener. I apologize for not communicating this change to you sooner. I am the person who left a couple of messages on your answering machine, I wanted to speak to you personally on this issue.

Star and the supplier need to work through current inventories, once this is complete, the New easy open lid will be available to purchase. I will be forwarding a few samples to you, with the new lid, as a courtesy.

Star appreciates your feed back and it has helped make our products more customer friendly.

Sincerely,

Jim McInnis

February 3, 1997

Mr. Richard Mackin
1298 Commonwealth Ave. #4
Allston, MA 02134

Dear Mr. Mackin:

Enclosed, please find free samples of our ice tea mix. Note the new flip top lids, per your suggestion. I hope you find that this makes the product more customer friendly.

Please continue to shop at Star Market.

Sincerely,
Jim McInnis

Sturm's
Village Farm

FAX:
414-596-3040

PHONE:
414-596-2511

A. STURM & SONS, Inc.
NANCY OMAN
215 Center Street/P.O. Box 287
Manawa, Wisconsin 54949-0287

THE ENCLOSED IS THE REPLACEMENT/COMPLIMENTARY
SAMPLE MENTIONED IN MY LETTER REGARDING YOUR
CONCERNS ABOUT THIS PRODUCT(S).

June 1, 1997

Dear All Parties involved with Star MArket Iced Tea,

As you probably are already aware, I have been involved in a
lengthy correspondance with companies involved with the creation'
manufacture, distribution and sale of STAR MARKET ICED TEA MIX.
This correspondance has lead to, amonst other things, the change
of the package design, as well as my reception of several free
containers.

It was brought to my attention that I did for you something
that companies pay experts thousands of dollars for, and all
I got was some free iced tea. Any chance I can get anything
else? Like credit on the package? "New packaging thanks to Rich
Mackin" with a small picture? Probably NOT, but it never hurts
to ask.

Anyway, a few weeks back, I was over my friend EVAN's house,
and was reading the series of letters to and fro to everybody,
and was going to open up one of the packages that you sent me
as a kind of climax, and was the going to serve iced tea to
all...

I read letter after letter, the pace growing. The tention began
to build. Finally, I ended the last one, reaching for the can.
I held it proudly aloft. I slowly began to open the plastic
lid, only to the yank it off dramatically. I took hold of the
foil "easy off" tab. I pulled slowly but firmly. It came off.
But that was a problem. The foil did not come off, JUST THE
TAB. Of course, thin foil is easily ripped off, and the mix
was far more accessable than before, and yet, I can't help to
feel a great irony here.

Please respond

Rich Mackin
1298 Commonwealth Ave #4
Allston MA 02134

NO REPLY!

167

RICH MACKINS ADVICE COLUMNS

On the cover, I am fighting the monster of Corporate America with a letter folded into a paper airplane. Am I going to kill it? Maybe not. But I am going to fight it as much as I can, and then I am also going to remove myself from the situation before it can get me.

I'm not trying to save the world myself, but hopefully I can inspire people here and there. Sure, one guy sending letters does little, but imagine if *everyone* did this. Imagine if everyone took half the time they do complaining about Corporate America and spent it complaining *to* Corporate America. Imagine if everyone researched all the companies they gave their money to and held them responsible for deserving the money.

I shirk the responsibility people want to give me for changing more than my share of the world. Once you say you want something to be better, people hold you responsible for making *everything* better. I hear people complain about anti-smoking groups because they aren't also stopping drunk driving. I hear people who have never helped a cause in their lives complain about animal rights activists for not being human rights activists. Unless you can show you have a more effective activism resume, who are you to just criticize? If anything, calling someone for only doing the action you see them do is being vain enough to think someone only exists when you watch them. Like when counter protesters tell someone to "get a job!" Having a job doesn't mean you are at it all day. Complaining that someone you don't know doesn't do enough "real" activism is as useful as telling them that they don't floss.

That said, here are some pages filled with my advice to people. You don't have to take it.

HERE WE ARE NOW ENTERTAIN US

Many years ago, I was at a party. I was the only person there over twenty-one. Most of the attendees were nineteen to twenty years old. It was at the apartment of a friend of mine from my hometown of Norwalk, Connecticut. And as a friend, I was invited to spend the evening with young people who attended Boston University with my friend Kirsten.

Eventually, the subject turned to the time-honored complaint, "There's nothing for us to do!" Like there are activities fairies out there that are neglecting their duty to keep young people in America entertained.

Biologically, and by hunger (which is essentially the same thing), we are motivated to search for food. Before grocery stores and 7-11s, people would need to do this for quite a hefty portion of the day. Other time was spent looking for a good place to sleep where saber-toothed tigers would not eat them. Then they started growing things and domesticating animals; food was closer, buildings were made, and a place to sleep was there. The time spent looking for food and shelter was reduced. This allowed for secondary activities, and eventually we wind up in modern times.

All these kids essentially were unhappy since they pretty much had everything they needed, but in getting everything they needed, had both free time (find a Indonesian sweat shop worker with a sixteen-hour day who has the major complaint of having "nothing to do") and the lack of satisfaction of *getting* what they need. Like the theory that something feels more like your own when you go and work for it yourself.

Anyway, rather than enjoy each other's company, they complained about not having entertainment, that not enough bands came to entertain them. Not enough *others* were there to provide *them* with entertainment. They were here; now, entertain them!

"*Why*," one asked me, "isn't there anything to do in Boston that isn't for the twenty-one and over?"

I blurted without thinking, "Because of you guys."

"What?"

Uh oh, I had to have a reason to say that! Luckily, one came to me. "The reason that there is nothing for you guys to 'do' is that you guys don't give anyone a reason to give you anything to do. First of all, instead of taking this time to organize yourselves and do something yourself, you sit around at this lame party, not even having fun, complaining about how someone else should provide you with entertainment. If all the clubs are 21+, why don't you all write them and ask them to have all ages shows? Ask the City Council and such to promote all ages shows. Ask bands to play all ages shows. Hell, why don't *you* organize some shows? And why do you need to watch something to be entertained? Why not do a zine, or have an Amnesty International-type writing campaign and make some sort of difference in the world?"

A few balked; a few got the point. I just got annoyed, partially with myself for my own uppityness.

Fast forward to a few weeks ago. A loft space had a show. All ages. In a private house, but open to the public. Donations to the "we dare to be free" anarchist collective. Hooray! Something to do! Early show, so the kids could get home on time. Totally DIY.

Of course, what happens? Well, as always, at any given time there were more kids hanging out outside than inside. (Between bands playing, this did make sense, since it was really hot in there.) Nothing wrong with hanging out in itself. But in a mainly poor, mainly black and hispanic family neighborhood, the sudden arrival of a hundred or so brightly haired, strangely dressed kids attracts attention. Attention also is not in itself a problem, but when all the high school kids are drinking.... it is.

"I can make myself puke!" said one girl, and after several botched attempts, she managed to do so a few feet away from the doorway to the space.

"Oh, wow!" I said. "That will really stick it to the system! Authority figures are quaking in their boots!"

When the cops came later, they quoted a violation of entertainment license law as the reason for the shutdown, but maybe if sixteen-year-old, pink-haired girls didn't visibly puke up beer while police cars drove by every few minutes, the cops would have cared less. Maybe if someone besides the three grownups at the show listened when the organ-

izers begged the kids to walk a few blocks to the park instead of hanging out drinking directly in front of the place, the cops would be less interested. Oddly enough, those of us old enough to go to the several cool bars with bands instead of supporting the DIY show seemed more intent on not screwing things up than the kids who came into the city just to go to it.

Of course, the cops did come. The show was shut down. The people who lived there no doubt got into some trouble, and I doubt they will put on more shows. I can go drink at a bar tonight, or write essays like this. But the kids have nothing to do.

ROAD TRIPS ARE GOOD FOR THE SOUL

Yeah, I have already talked about touring and protesting a lot. Obviously, they are both things I do often, and they do share (at least most of the time) the common thread of involving a road trip. Without question, the road trip is an important American tradition. I mean, if we are gonna rape the land for all these highways, we might as well make use of them, huh? I know it is far more punk to train hop or take the Greyhound, but I never cared about how punk I was, and you know, I prefer the control of planning my own schedule instead of following that of a company anyway.

Road Food

One thing that humans need to do is eat. For many people, road trip food consists of one of two things: convenience food, which means junk food, and fast food. Neither of these are especially healthy or a really good use of your food dollar – not to mention you'll be supporting some of capitalism's best companies. Other options take a bit more work and thought, but I find that they are worth it.

Planning can make a trip much better on all levels, but especially food-wise. Driving through Texas in July means that if you pack anything that will spoil, you better eat it in a few hours, and even the coolest cooler won't keep anything for a three-week trip. To start the trip right, I enjoy making a few sandwiches for day one and then stocking up on non-perishables such as peanuts and dried fruit (and let me make an uncharacteristic product endorsement for Trader Joe's dried pineapple chunks). Consider cooking some stuff ahead of time or using any kitchens along the road to make extra meals. I know I much preferred the bread with garlic and pesto spread I ate in Portland than any mass produced meal I could have had.

My friend Kristin Forbes brings on tour a small hotpot that plugs into her cigarette lighter, along with dried rice and beans. She cooks cheap, simple, healthy food in her car. This isn't exciting or luxurious, but

175

means pennies for a decent meal instead of spending precious road dollars on fried junk.

One trick I learned is how to recognize towns on highways. On big highways, everything you know about the immediate surroundings is based on the signs on the side of the road. As a whole, you will see a sign for every highway-side McDonald's, but rarely for any small local businesses. (One major exception to this is in Pennsylvania.) If you are driving and see only two signs for fast food chains, more than likely, those are your only options. But if you see a dozen or so chains, that means there is enough development there, and there's a good chance other businesses are nearby. Get off the highway, onto the main road or route or whatever all the chains are on, and drive maybe a mile. You will probably see a supermarket, which means you can buy fruit and veggies and other food that is fresher, healthier, and cheaper than fast food. You will almost definitely see a Mexican or Chinese restaurant, each of which tend to have healthier and more vegetarian-friendly options than the chains. Also, I find that Chinese food takeout usually is about the same price as fast food, gives you much more food for the buck, and is easier to split than a sandwich.

Oh, and for people not used to the south, grits are pretty much oatmeal if it was a corn product. I like grits a lot, but they aren't a big deal.

Road Beverages

Another thing humans need to do is drink water. That's right, water. Indeed, we can drink coffee (and if anyone has ever driven with me on a trip, you know how much coffee, road trips, and me are connected), soda, or any other number of beverages, and I will get to those in a minute. Some of you drink that fancy bottled water. What I do is get a twelve-pack of bottled water and just refill the bottles. This allows me to have a supply of bottles so I can stock up on water when it is plentiful and always have a surplus. I only need to deal with an easy-to-hold bottle at any given time, and I don't have to worry if I left a bottle behind somewhere, because I have eleven more just like it. After some trial and error, my water bottle of choice is Adirondack. It's a bargain brand, has that nice sports top (i.e. a nipple. Not that anyone else will admit it.) for ease of drinking and driving, has a good bottle consistency for pleasant holding and squeezing, and it maintains its shape even after having big, heavy things sit on it. In case you care about the actual water that comes in the

bottle, look for "bottled at the source" on the label. If the source is not where the water is bottled, you don't know what it goes through before bottling.

Almost as needed as that 64 ounces of water a day is coffee. At least for most of us. A road trip just isn't a road trip if I don't feel addicted to caffeine at the end. As a New Englander, I of course cannot speak highly enough of Dunkin' Donuts. At the same time, if anyone who reads this goes to Starbucks, I would rather have you stop reading right now and go stand in the corner and think about how bad you should feel. Road coffee can be about flavor at points and survival in others. I have downed horrible, horrible stuff at 3 A.M. and been happy because all it needed to do was keep me awake, and thus alive. I maintain that all coffee drinkers in our society should have a travel mug. Use it, reuse it, abuse it. If you have a travel mug, free coffee can be had at many service centers (the kind that are like food courts). You merely refill it and walk out. There, a scam. Many truck stops charge you more for a new coffee than if you bring in your own mug, so a small coffee in a new cup costs about as much as a thermos refill.

Traveling means new experiences and for me, my one blatantly consumer habit is weird new sodas. A Coke is a Coke in Boston or L.A. But only on a road trip can a Northerner experience Cheerwine or Sun Drop. Local sodas tend to cost less than the majors, so I heartily endorse experimenting. Some day I will have my soda label museum. If you are going to eat at chains and drink Coke coast to coast, stay the hell home.

Keep in mind that you can hold a gun to your passengers' heads and tell them to make sure to not leave any bottles in the car, and you will still get home to find thirty-seven bottles of iced tea, juice, and cola each with an inch of backwash on the bottom. When your trip is done, do a once over. The stuff gets nastier over time.

As for alcohol, I get drunk all the time when travelling, *when I get to my destination*. But, as amazing as it is for someone from a puritan state to see highway rest stops with built-in liquor stores, don't drink and drive. I have a friend who was run over by a drunk and can't talk or walk right any more. If you drink and drive, I'm going to make friends with a big guy in your town and he is gonna kick your ass.

Road Stops

Rest stops, typically, are state run and are basically a rest room, a water fountain, and some vending machines. Most have tourist info and

maps. Some even have staff who will tell you whatever you need to know. Some have free (bad, very, very bad) coffee provided by quirky old men or Boy Scouts. Some frown on you sleeping in your car. Some are there just for that. Many have picnic tables to eat that food I told you to bring yourself. I endorse rest stops and mock those who drive by them only to pull off an exit and search for what rest stops provide so readily.

"Centers" of the travel and service variety are usually best on toll roads, where you are held captive by the toll and don't want to exit until you get "there." These often have a few eateries of various quality and styles, a convenience store, and possibly any number of vending machines, video games, squished penny machines (hooray!), and other diversions. I also endorse these if for nothing else but the cultural importance and free anthropological amusement. The difference between these and truck stops is the difference between art and porn. I can tell you which is which, but sometimes the line is hard to explain.

Truck stops, as a rule, cater more to truck drivers while the centers cater more towards tourists and less wizened travelers. One looks like an auto parts store and the other like a mall. Truck stops tend to be good places for comfort sit-down food and cheaper coffee.

And of course, depending on where you drive, you can stop at tourist attractions, roadside museums, stores, farmers markets, and so forth. Explore, damnit.

Road, Um, Bodily Waste

First of all, keep in mind that, in nature, things eat and poop. The poop falls on the dirt, becomes more dirt, and then more things can grow in it. In our society, we poop into filtered, drinkable water which we flush away so all our poop hangs out. Then we go buy chemical fertilizer to make things grow. Although I am far off from saving my poo for fertilizer, I merely mention this to say that if you need to go in a bush, you are doing the bush a favor.

I keep a roll of toilet paper with me in my car anyway. I have yet to need it for such, but I find it to be good for nose blowing and stain wiping. The tube in the center is good to hold used tissue until you can get to a garbage can, assuming you are like me and that grocery bag you earmarked as garbage gets filled halfway through day one. Many people will mock you about the toilet paper, but not when they need it. (Also, a package of baby wipes kept in shade is nice if you are travelling anywhere hot.)

178

Here is the most important thing I have to say. This is the rule of road trips, and breaking it has ended relationships for me. WHEN YOU STOP, YOU PEE. NEVER PASS UP A PEE BREAK. I don't care if you don't think you have to. Go. You probably can, even if it isn't a dire need. If you try and fail, you lost thirty seconds, max. If you fail to try, you will just have to go in fifteen minutes and annoy your companions.

Another thing about peeing, at least for men: the urinal thing. The American urinal thing is the most amazing bit of sociology I have ever encountered. Somehow, it became such that you are supposed to leave a buffer urinal between you and the next guy. Failure to do this is a source of great amusement and occasional concern of beatings from homophobes. Peeing next to a boy under twelve will worry the father. Two men will talk to each other if they have that buffer urinal, but freak out when you use that one and thus enter into their bathroom conversational world. Oh, and if a guy looks like he is jerking off next to you, especially if he seemed to zone in specifically to the one next to you, he probably is, and probably is looking for "a hand." I dunno, I believe that two men expressing their love for one another is as beautiful as any other expression of love, but that still doesn't make the idea of getting picked up by a stranger in a McDonald's toilet appealing to me.

Actual Driving

Drive with drivers. By this, I mean that someone who drives usually makes a better passenger than someone who doesn't drive. If you wind up on a road trip with someone who doesn't have a license, or got one years ago and has been living car free (which is not a bad thing; in fact, it is often spiritually and ecologically much better), it might be a good idea to make sure another driver is along for the ride. Not only can a driver drive, but a driving-minded person understands what driving is like, what traffic is like, what having to watch for signs, obstacles, other cars and people to hit, and all of that is like. A driver understands that it takes an hour to get from Boston to Providence at 3 A.M., and two hours at 4 P.M., and that it is just a bad idea at 5:30 P.M. on a Friday.

The person who is riding shotgun is navigator. While I agree with most of the ideas of anarchism, I also believe this is a law that must be obeyed, like gravity. I have witnessed the horror of shotgun calling gone awry when someone is sitting shotgun because they called it, but the only person who knows how to get to the destination is stuck in the back. This makes it hard for them to see, communicate, and often pay attention. On

the other hand, if there is not one person who knows more about the directions than anyone else in the car, whoever rides shotgun should have the map and read directions. It is also very important to have the map or directions open and at hand. Two road trip tragedies include passing something suddenly or missing an exit because of directional issues and the death of a road map at the feet of a passenger. A road map that has missing and dirty pages is not the world's most useful map.

It's a good idea to decide ahead of time how much exploring and side trips you want to make. If you're on college summer break and have two months to drive around aimlessly, your trip can have a less planned agenda than if you are merely traveling to a destination.

Road Tunes

Road tune helper #1 is the mix tape or CD. It provides variety, learning experience, and the chance to make a customized mix tape for that trip. Often, friends will make other friends mix tapes for road trips. It's nice.

Road tune helper #2 is the CD wallet. For years I thought of these as merely a redundant product until I realized that driving for more than a few days made me want more music than I wanted to carry in terms of a box of jewel cases. A decent CD wallet goes for $10 to $30, depending on the number of CDs you want to bring on your trip. Just make sure that you know what some of your more arty band CDs look like, because some artists forget to print things like who they are and what album is on the pretty pictures.

What I have found as a good rule is to have each road tripper present their music and have another person select from that collection. This way, I know I will like what you select, but you get control over what we listen to.

The driver gets veto power and more control. 3 A.M. driving calls for loud, fast, and manic. L.A. freeways call for lack of distraction. The other people in the car should remember that they get to listen to other music after the trip is done, but only if they survive.

Technically, you can also talk to each other. Sometimes, this will just make you argue. I have found that if a passenger can read without getting carsick, reading out loud combines entertainment with the niceness of hearing a human voice, but keeps you from getting sick of each other.

180

Other Stuff You Need

I have a few light sleeping bags I keep in my car. The way they are rolled up, they are pillows. Unrolled, they are sleeping bags. Unzipped, they become blankets. I read in a zine that a hooded sweatshirt with a balled up T-shirt makes for a great pillow. A basic first aid kit, tool kit, a few flares or some sort of emergency light, flashlight, jumper cables, tire sealant, and spare tire should be in every car, really. You might also want to keep a gallon of water, extra gas in a safe container, and things like a shovel or anything else weather might call for. Keep sunscreen in the car. Even in winter, hours of sun will get you, and that little triangle on your arm will be bright red when you get there. My last tour I had one arm that was half red, one arm that was 3/4 red, and a weird red spot on my left knee from site-specific sun.

So, that's about it. Getting there is half the fun.

SOME RANDOM THOUGHTS ON BIKES

I just finished a book on Critical Mass (a monthly bike ride, traditionally on the last Friday of the month, during the evening commute) and was too sick to ride in the NYC Critical Mass on Buy Nothing Day. (At the time I was in Norwalk, located in the penis tip of Connecticut, almost in NYC, for Thanksgiving. A lesson to those who don't eat a lot of dairy: ask your crazy relatives if they loaded up potatoes with sour cream before eating.) So, because I have all this pent-up bike energy that I doubt would be satisfied with a ride in the 20 degree Boston weather, I write instead.

An old roommate once noted the trend of bike punks getting huge in the area and asked where all the bikes were last year. Were all the bikes in garages getting lonely? His wording was mostly in reference to his belief that these kids wouldn't still be biking as much in a year. (Indeed, the kid who got "bike punx" tattooed on his knuckles started the laser removal before a year passed. Then again, this is someone who lectured me on straight edge over the summer and was drunk off a 40 last week.)

But, for all my roommate's pointed mockery, he failed to see the logic of the bike as a punk accessory. While most bikes are the products of corporations, the companies that make bikes are less likely to be tied with crime and pollution, and riding a bike doesn't require gas from any of George Bush's friends' companies. A bike is metal, tough, can be maintained yourself with some minimal skills and training, and can easily be personalized. Bikes can be cheap for the poor, expensive for the Hot Topic trust punks, or even built from scratch for the truly DIY punks. If not totally built from scratch, bicycles are easily chopped and remade into works of art with pedals, and such work is not as scrutinized by the state as a car would be (and with good reason, since bikes also don't have polluting emissions.)

So, here are some random thoughts on bikes.

Art and Protest Bikes

The art bike is easier than the art car in that you can add temporary decorations without as much concern of them flying off when driving. (And if they do, you can more easily turn around and get them.) Unlike dressing in costume as a pedestrian, an art bike allows some detachment (you aren't a freak; you are a person with a freaky bike) and easy getaway if you live somewhere with a lot of frat boys or rednecks who disapprove of signs of creativity. Bikes are easily painted for the novice, and can have any number of wings, attachments, or even outer shells created for them. For those who don't want a major production, simple decorations, such as a sign in the front of the handlebar (where the number would be on a BMX bike) are easily added. My friend Kelly mounted a plastic skull in the center, so the handlebars gave the appearance of horns. A luggage rack (useful on its own right) makes for a good sign mount or flagpole holder. I have a few flags (pirate, corporate America) on light wood poles that easily affix to the angled rear frame of my bike's rack. This allows an angled display, which keeps the flag away from me and the wheels, and also lets the flag hang down, making a nice flag wave as I ride. Going to a protest? Why hold a sign when you can have a rolling mini billboard? Not going to a protest? Why not state something anyway as you ride to work, school, or wherever? Again, the ride-by aspect of the bike allows for a sense of commotion and yet anonymity. You are seen and then gone. This is especially optimal for times when you want to make a statement and not stick around to answer follow-up questions or get beat up.

Bike Locks

If you have a bike, get a lock, and then lock your bike. Ideally, you lock your bike by having the lock go through a wheel, the bike, and something that is attached to the ground or a building. This is an important point. I once saw someone lock a bike frame to a four-foot-tall signpost with the sign no longer attached. If I wanted to, I could have easily lifted the bike and ridden away on it, the only function of the lock being an annoying noise as it clanged against the frame. If you have things like easily removable wheels or a detachable seat, lock them, too. I mean, sure, you know your area better than I do, so maybe you don't need to do all this, but as a whole, I find that in most cities, thirty seconds of bike lock time is worth the amount of time it might take to carry a bike with

one wheel home. If you can't lock the bike to something like a signpost or fence (or in utopias such as Minneapolis, a bike rack) at least lock the wheel to the bike. Someone could still carry it off if they really wanted, but at least they can't ride it off. An unlocked bike is not just something to steal; it provides the thief with a getaway vehicle. This would be like leaving your car keys in your car door. (Or repeatedly leaving your friend's keys in his car door, which is partially why I don't bring a certain person on tours any more.) Also, make your bike look either personal or crappy. Decorate it with stickers, whatever. Nothing appeals to a bike thief more than a nice, new, perfect bike. Especially if you are dumb enough to have mounted to your bike a lock that you didn't use. I know people who have stolen unlocked bikes with locks still in the mounts, just on principle.

Helmets

Bike helmets have got to be the stupidest looking things on the planet, arguably after faux hawks and Carrot Top. Riding without a helmet looks cooler, but getting brain damage tends to make you look not so cool, so a good compromise is a skate helmet. Football and other helmets not only work, but also add that thrift store mismatched fashion the kids are into. Just make sure that you protect the parts of your head that are most likely to smash into something. Also, don't decorate in ways that defeat the purpose, like drilling holes that allow the helmet to crack, or using paints and glues that affect the chemistry of the thing.

Bike Riding Tips from Your Friendly Dictator

Bikes are vehicles. This means they are traffic. This means they belong on the street. On one level, this means that people driving cars will have to deal. I am not saying don't take up more room than you need to thwart cars, nor am I saying to disregard the physics of a car-on-bike collision. But you have as much right to drive your vehicle as the motorist, unless there are signs saying otherwise. On another level, I am saying that sidewalks are called side*walks* for a reason. Sure, in some parts of Boston, the sidewalk is the size of the street, except one has lots of fast cars and one has a few slow pedestrians, so the cyclist usually chooses safety and sanity over technicality, but as a whole, riding your bike on the sidewalk is just being a jerk. Use your judgement, but consider if your biking is worth annoying everyone else. If you need to be on the side-

walk, consider that maybe you can coast more and not have to pedal at breakneck speeds.

Bike Law

One thing that is fun about riding in Critical Masses is finding out how little cops know about bike laws when they stop you. The problem is, this is only funny if they just stop you and let you go. This is less funny when they take you in. Please always remember, just because a cop does not have the legal right to arrest you does not mean they don't have the physical ability to try. All the zine-read "what to do when a cop talks to you" material does nothing when it comes down to a cop *wanting* to arrest or otherwise annoy you. One good defense is to learn local law regarding bikes and print that info out. One friend even made cards with this to distribute, should the need arise.

Bikes as a Statement

Well, I don't know how much of a statement this is, but once, when I worked at a cushy white collar job, our company won a bunch of things and rented out a room in a fancy pants nightclub. I must admit that it was fun watching all the people paying for valet parking, confused to see me pull up in my bike (cardboard box duct-taped to the rack, no less), and walk in. I am also the type of guy who always goes for the "other" category on surveys, filling in my bike description if something calls for a car. (Yes, I know I have a car, too. Hey, at least I am not one of those people who has a "one less car" shirt when I ride even though they have a car; it's just not being used. That's like saying you are vegetarian because you aren't eating meat at the moment.)

Bikes Where You Don't Expect Them

I have bikes *and* I have a car. Therefore, I have a bike rack on my car. I find this great when travelling. As much as I dislike car culture and sprawl, my car can get me from Boston to DC in a day and a bike can't. And for the price of one train ticket, I can get gas money to drive a few people all that way, and their too-heavy-to-carry stuff, and their bikes. Aha, then, when we get into DC, we can park and ride bikes around! Bikes are great travel accessories. Park your car in most major urban areas and see if you want to get back in it and look for another parking space every time you go somewhere. Or you could take public trans-

portation around the city, but that usually means spending lots of money on taxis and busses? (Well, you could walk, I guess.) But if you have a bike with you, you can explore faster than if you walked. You can get around without parking again and again (and paying again and again as some cities would have you do), and if you make a wrong turn, you can much more easily correct the situation than with a car. (Ever get lost in Boston? Make a wrong turn, and the maze of one-ways escorts you to a totally new part of town.)

I have brought bikes with me to large protest marches, and the difference in the experience is amazing. With all my heavy stuff on the saddle or rack, I am unencumbered (well, except for the bike I have to push). If I want to see if I know anyone else at the march, I can much more easily ride up and down, or even ride to the beginning and watch the whole thing pass. Need a bathroom break? Ride off a few blocks and return before the march is too far to track down.

Be prepared. If you ride a bike somewhere that people know isn't your hometown, they will assume you biked all the way there.

Don't have a bike rack? Don't want to lug a bike on a train? Consider a folding bike? There are a few kinds out there. Some look like tiny bikes with long handlebar and saddle stems. I have a Strida (see www.strida.com). A Strida is fairly priced for a new bike device that is lightweight and folds up into approximately a 45" x 20" x 11" space and can be rolled when folded. When in bike mode, it looks like a triangle with wheels, a handlebar, a seat, and pedals. Heck, even if I never traveled with it, it's a mobile work of art and just plain makes people happy. One word of warning: folding bikes tend to be far less maneuverable and harder on your ass for longer rides.

Critical Mass as a Microcosm of Why Anarchy Won't Work Just Yet

Most cities by now have a Critical Mass. It could be big; it could be small. It could last a long time or a short time. It might have blatant political messages or just be a bunch of people riding together. Once it is decided somehow that it will meet at X time at X place, it is generally without any other signs of leadership or predetermined decision making. One of the best parts of Critical Mass is the lack of any official organization. Of course, one of the worst parts of Critical Mass is the lack of any official organization. To say that there is no leader is never really true. Like in many social situations, the lack of an official leadership does not

186

mean that some people will not take control, or at least attempt to. Others will willingly follow. Still others may not willingly follow, but will either go along for lack of reason not to (i.e., not wanting to go a proposed route, but having no other route to propose) or because they become passive. These are often the people who complain about things, perhaps even drop out of the ride/ scene/ society without doing anything to improve that.

Of course, this is a simplification. Some people ride in a Critical Mass every month (or go to every punk show, or vote in every election, etc.) and try to influence others, only to grow cynical by lack of change, or even change in the opposite direction. In Critical Mass sense, one recurring theme is the "angry young white males" (which they usually are) or "testosterone brigades" who are unfriendly and aggressive and see the ride as anti-car, as opposed to simply pro-bike. To these types, the ride is an excuse or chance to harass drivers, perhaps because these testosterone brigades ordinarily feel harassed. These riders are generally the minority, but they are a very visible and outspoken group, and so seem to represent the entire group. The problem is that the bulk of the group has little to show, besides riding without conflict. So, many more peaceful riders are tempted to ride next to the provocateurs, uncomfortable with the idea of talking about the subject, and so merely post about it on chat groups the next day, or perhaps merely not show up again. What this means though, is that the peaceful majority dwindles, thus fulfilling the prophecy that the troublemakers are the spokesmen for the group, because soon they are the majority, if not the only ones left. This is something I never understand. Essentially, it is like saying, "I don't like the way you do things, so I will let you do them without voicing my opinion or providing any counter point."

This is a sad point to be made from someone with a patch that reads "My bike takes me places school never could," and it's one reason that I *do* try to ride in as many masses as I can (and contribute to publications, vote, go to meetings, etc.): because I subscribe to the "if I don't care, why should anyone care?" school of thought. If I don't want Critical Mass to be viewed as a bunch of hooligans, I should be there to act *not* like a hooligan, and to ask the hooligans why they are acting that way. Effecting change isn't easy. I suppose if it was, it wouldn't be change. Of course, then again, having fun takes energy, too.

Just like riding a bike.

BEYOND ROCK AND ROLL

Anyone who knows me or my rants knows that I hate the whole "here we are now, entertain us" mentality of most Americans, as well as their complaints that "there is nothing to do." This is usually heard by suburban kids who mean to say, "We want more bands we like to come to town." And I hear it as, "We are so spoiled that we can't think of anything we want to do to improve anything, so we will whine about it."

Anyway, in young and punk circles, "something to do" does usually imply seeing a band, or going to a club or something involving rock music. This is silly and simplistic. Let me school you guys on some fun stuff I know about that goes beyond the whole "show" mentality. This is mostly stuff in my backyard, but hopefully it'll give you insight into what could be in your town already or with some work on your part.

(Keep in mind that I do live in a city with eighty-some colleges and a lot of history, so I do have some advantages. And since I drink, some of these fun things involve alcohol, which makes certain situations age related and socially lubricated in a certain way. Use these as springboards, not rules. Also keep in mind that some people go to a big school, live near cool clubs in a big city, and still watch bad TV and sit in silence on a Saturday night.)

One of the weirdest things to go see in the Boston area is called Kaiju Big Battel. (Yes, like Battle, but spelled wrong.) The basic concept is art students interpreting a Godzilla movie in a wrestling context, so people in elaborate monster suits wrestle in a ring filled with model buildings. The suits range from twelve-foot, lizard-like things to sandwich costumes, and when I say wrestle, I don't mean wussy punch pretend fighting. I mean full-on, pick up and throw "rasslin." Meanwhile, multi-lingual announcers, weird background music, and a between-match set of antics that makes WWF seem tame logically complete the show. Not that I expect every city to have something like this, but it certainly gives you an idea of an atypical activity. Some shows even have entire crowd interaction. One show was at a college where many students had no idea of

what they were into, and it was hilarious to us veterans of the Battel to see randomly handed out Dr. Cube and anti-Dr. Cube signs being held proudly by people who had no idea who Dr. Cube was, nor why they would care.

Slightly easier to recreate in any town are the Guerilla Poets. Formed by Emerson students some years ago and still thriving (even though the core members are now all graduates with real jobs), the idea of Guerilla Poetry is the reading of poetry. Out loud. Anywhere. On a nice day, a public square or park, on a rainy or colder day, the Boston Guerilla Poets might start spouting in a Burger King until they get kicked out, or one may jump on a table in a food court in a mall. Until they get kicked out. Being kicked out of somewhere often means leaving "Poetry Free Zone" stickers. The local group meets Sundays at 2 P.M. and emails places weekly on a list, but feel free to randomly start speaking art when it strikes you.

Critical Mass is something that I would guess most readers know about. Simply put, every last Friday of any month, people meet somewhere and ride bikes together. The only real "official" decision is when the meeting place is made, and once that happens, it tends to be the meeting place forever. Some cities have aggressive rides when riders block traffic; others are just fun group rides. But you don't have to limit your ride to once a month. During a blackout (actually, it was a deliberate "rolling blackout," but anyway...) my friend Turtle organized a night-time blackout bike ride, meaning we all used battery power (or not) to get out of the house and not rely on the electric grid for a while. And let me say, you get some strange, amused looks when a bunch of pirates zip by cars on bikes. A Boston area man named Lucas has a couch mounted on a platform with bikes on either side, pulled by the bike he rides. You can imagine the interest level that adds.

You can of course have any sorts of themed bike rides, and you can even throw a theme into the old keg party. Yeah, yeah, toga and all that, but remember how fun it was when you were eight and you had a theme to the party? For people my age, *Star Wars* might jar a memory or two. My friend Chris celebrated his birthday with a pirates vs. Vikings party. Despite what you might guess as a decidedly pirate leaning backdrop, about 70% of attendees were in Viking garb. The costumes alarmed the workers at nearby liquor stores, who knew Halloween was months ago. My one word of caution: if the local sports team is playing a team with a pirate mascot that day, don't walk in public as a pirate. Not being

189

a sports fan, it was after three general profanity throwings and a "Raiders Suck" when I realized what team the Patriots were playing that day. Odd sports-fan-related issues aside, having two hundred people in character discussing how, if you think about it, Vikings are a kind of pirate after all, sure beats the typical between beer sips banter. In any case, while "normal" parties came and went, the pirate vs. Viking party was something people were looking forward to for weeks, planned costumes for, and surely will have photos that are recalled more specifically than photos to which you say, "Here I am at some party. I think in 2001, I guess."

Perhaps the best theme parties in town were the monthly Blind Man's Balls that Kevin P. O' Brien would throw. Okay, let me set the stage with Kevin O' Brien. This guy used to work on big Alaskan fishing boats six months a year, which meant he made enough to live all year, but had no rent or food expenses for half of it. He was the guy who would disappear, show up months later with a huge beard, and lots of money to buy beer for everyone. This was the kind of guy who you wouldn't see for a year and when you did, he had a new scar. When asked, he wouldn't tell you the story. He would hand you his newly made zine with the story in it. Blind Man's Ball events could easily be described as a poetry kegger. There was a big room. There was a stage, and he had an open mic that you could sign up for. While a keg party was going on. So it had the drunken stupidity of a kegger diminished by poetry, and the false air of pretentiousness cut down by a keg. Nowhere else have I seen skinheads party with seventy-something published poets and get along great while doing so. Of course, this was merely one good example of the "art" party. Many other people I know have all sorts of readings or group mural projects. Hell, two guys I know would clear all the furniture out of their apartment (hiding it with a friendly neighbor) and have art gallery nights at their house. They also had indoor bowling.

Near my house is an art collective called Pan 9. Instead of having parties, they have insane mixed media events combining performance art, comedy, atypical music (like the band Livesexact that mounts drum heads in stuffed animals), theatre, and visual art. For several years, a group at MIT had monthly "show and tell" nights where people would perform or show off weird stuff they had or do strange scientific experiments.

If you want to make your party more than merely themed in an entertaining way, there is always the Amnesty International write-a-thon. Or you can get a bunch of your friends to work together volunteering for

the same cause. Stuffing envelopes sucks as a task, but if you and your friends can talk over coffee or beer at a place of business, why not over altruistic paperwork? If you do a zine, there is always the zine party (or, as my circle calls it, the zine sweatshop) when you just get everyone together and do the grunt work together. It's like a latter day quilting bee.

Hell, it even seems like a lot of people are getting into quilting bees. And sewing circles. Hell, why not be productive and fun? Not only does this mean being social while getting something done, but these groups could also spawn punk and indie craft fairs and the like.

Of course, you can always simply add an entertaining spin on something already going on. Instead of watching a parade or marathon, see what you can do to add to it. This I will leave open to the imagination. One semi-related idea is at the last Beantown Zinetown (zine fair), Zhenelle of *Born Ready* and her friends would applaud every now and then. It was "because they are positive." It was funny to watch other people join in the clapping with confused looks.

You can find entertainment and interest in day to day life, not just Friday and Saturday nights. (Although a lot of punks know this from Tuesday shows, since the clubs reserve weekends for bands with more draw.) You don't need something "to do" when you are someone who just does things. Pranks, situationism, good deeds... Have you seen *Amelie* or *Fight Club*? Make the most of each day. Heck, if you are a scary looking, unwashed type with spikes aplenty, simply watch what happens when you hold doors open for people. If you have more ambition, try doing what some of the Pan 9 people did. They made up some fake quizzes that made no sense and took to the streets and got them filled out. The answers provided humor for years to come.

And, as many of you already know, protests are your best entertainment value.

Here you are now, entertain yourself.

Or, as the song goes, if you're bored, you're boring.

ALSO AVAILABLE FROM
GORSKY PRESS

DRINKS FOR THE LITTLE GUY by Sean Carswell **$10 ppd.***
paperback — 279 pgs.
"The best book about a carpenter since the Bible."
 —Flipside Magazine

DEAR MR. MACKIN... by Rev. Richard J. Mackin **$10 ppd.**
paperback — 200 pgs.
"Richard is on to something here, something big... If you are not hip to Mackin, you are missing out...: Mackin is a witty genius."
 —Factsheet 5 (editor's choice)

THE OTHER CANYON by Patricia Geary **$10 ppd.**
paperback — 130 pgs.
"The Other Canyon is a compelling and endlessly fascinating book. Startling, delightful, eerie, and completely compelling."
 —Tim Powers, author of Last Call

GLUE AND INK REBELLION by Sean Carswell **$10 ppd.**
paperback — 130 pgs.
"Sean Carswell is a wonderful story teller. Reading his stuff makes you laugh, and makes you think."
 —Howard Zinn, author of A People's History of the United States

THE UNDERCARDS by James Jay **$8 ppd.**
paperback — 100 pgs.
"Its cast of stooges, high-flyers, and maulers will, by turn, make you guffaw out loud, gasp with awe, groan with grief. This book puts the smack-down on poetry!"
 —Jim Simmerman, author of Kingdom Come

PUNCH AND PIE edited by Felizon Vidad and Todd Taylor **$5 ppd.**
paperback — 160 pgs.
A brand new anthology featuring fifteen short stories by fifteen different underground authors.

FOR A COMPLETE CATALOG OR TO ORDER ONLINE, VISIT:
 <www.gorskypress.com>

FOR OLD-FASHIONED MAIL ORDER, SEND CHECKS, CASH, OR MOs TO:
 GORSKY PRESS
 PO BOX 42024
 LA, CA 90042

*("$10 ppd." means that the total for the book, including shipping and handling, is $10)